IRON SPIRITS

IRON SPIRITS

Editors

Nicholas Curchin Vrooman, Project Director
Patrice Avon Marvin

Photographers

Jane Gudmundson
Wayne Gudmundson

North Dakota Council on the Arts
Suite 811 Black Building
Fargo, ND 58102

November 1982

This project is supported by a generous grant from the National Endowment for the Arts, Folk Arts Program. Additional support comes from the North Dakota Council on the Arts, the Germans from Russia Heritage Society and the Catholic Diocese of Fargo. Thank you.

And special thanks to Phyllis Hertz Feser who pointed us in the right directions.

Designed by Vern Goodin

Printed in the United States of America by Knight Printing Company, Fargo, North Dakota.

First edition

CONTENTS

To the memory of the cross makers and to the people of North Dakota who opened their hearts, allowing this story to be told.

FOREWORD

North Dakotans should take a special pride in the subject of this volume. From its pages emerge the soul of our state through the voices and images of some of its people.

This book considers the heritage of the blacksmith-created iron grave crosses which originally were prevalent in the Black Sea area of southern Russia. Catholic immigrants brought the concept with them when they came to North Dakota during the early years of our history. The voices contained in this volume are the voices of those early immigrants and their descendants. More than that, they are voices to which all of us can relate. They speak of a deep and meaningful part of their owners' personal, community, ethnic and religious lives. They speak also to the spirit of North Dakota itself.

Blacksmithing is an epic occupation, fundamental to the development of our agricultural economy. The religious experience which these crosses symbolize is equally fundamental to our civilization. These two factors combine to form a body of art, a beautiful balance of the sacred and the secular, an achievement worthy of praise. The work that the iron crosses represent and the meaning they hold are an integral part of the foundation upon which North Dakota society is established.

ALLEN I. OLSON
Governor

INTRODUCTION

Life is fleeting. Eras pass quickly. What time we have becomes lost to the winds of change. Only on occasion are we able to stop and take gauge of where we are and what we've accomplished as a people. Tradition marks time in our lives and represents a distillation of the strongest values, beliefs and desires that people have chosen to hold and share, defining their uniqueness within the common whole. It is the traditional aspects of daily life, a mixture of memory and material objects, that live on leaving a legacy to the future of who we are and what we've been.

This book is about the tradition of blacksmith made iron grave crosses, the people who made them and the communities they served. It is a story of hard work and faith. The crosses are a prolific and inspiring body of work by a small number of people and can be considered some of America's finest folk art. Through them we hope to understand and appreciate art and culture in a very fundamental way.

The story is predominantly that of the Catholic Black Sea German Russians, but also includes Catholic German Hungarians, Ukrainians, Poles and Bohemians, all of whom came to the steppes of the New World from the steppes of the Old, the Ukraine, Russia. These people settled throughout the Great Plains as well as the pampas of Argentina. The iron grave cross custom was brought with them from the old country and in North Dakota was practiced from the first arrival of immigrants in the 1880's through the 1940's.

The North Dakota Council on the Arts undertook the project because there was a need to document further this important form of American folk art and to express in a broad public manner the beauty and cultural value of the grave markers.

A survey was carried out within North Dakota boundaries to identify cemeteries where handmade iron crosses exist, to gather descriptive information on each individual cross, and to learn who the cross makers were and what the geographic distribution of their styles and body of work was. Various other questions needed to be considered. Of the iron cross heritage, how strong a memory remains with the descendants of the original immigrants? To what extent were the local blacksmiths influenced by tradition, by family concerns of the

deceased and how much by their own creativity? How closely was religion tied to the work process? How were they made? What symbolic forms are utilized in the cross construction? What meaning do they hold in contemporary home communities? The material in this book begins to answer some of these questions.

Field work for the project entailed both a verbal and visual dialogue at the homes and cemeteries throughout the state. Seventy-eight iron cross sites have thus far been located and documented. Hundreds of people were talked with in the search for the few who could give us confirmed information on the cross makers. This is not a comprehensive study. It does, though, give a sense of the breadth and depth of community knowledge concerning the crosses and provides photographs representative of what can be seen in North Dakota graveyards.

Four areas of concern are developed in the publication, which will hopefully aid in the protection of this valuable contribution to North Dakota's cultural heritage: to recognize and honor the cross makers and their work; to exhibit through photographs the dramatic and powerful visual statements the crosses make on the landscape; to present a sense of community understanding through personal voices from within, giving hint of how time works to both reinforce and whittle away at human endeavors; and to provide an academic folkloric perspective which poses a cultural context in which the crosses belong.

The people within the communities to which the custom belongs know more than any the memory and emotion the crosses hold. This book is made by them and their words. Common language is immensely important, informative and wonderful to hear. For these reasons, when traveling the state talking with people, we listened for everyday conversations and personal accounts.

The voices presented here are real voices. They were in most instances recorded in the home setting of the speaker. Some have undergone editing to develop continuity and to construct storyline. But the language style and the intent of the speaker have not been compromised. We have synthesized the major threads of thought and concerns expressed by individuals into a cohesive, presentable literary format designed for public access and readability. The dialogue represents community notions expressed in many ways by various people across the state. First names only are used so that the speaker takes on an ''every person'' function, speaking for the community as a whole. Place names and locations have purposely been omitted in the need to protect the crosses.

It was the singular and captivating beauty of the iron grave markers on the plains of North Dakota which inspired this project and gave it form. As with all art, the appreciation one gains from the crosses is a matter of personal taste and acceptance. And as in all work, there are varying degrees of technical expertise displayed. But beyond aesthetics and technique, the crosses, reflecting one of the most elemental forms in nature and having been stylized throughout human history by all peoples, can be seen in yet new, original variations of astounding diversity. The iron crosses of the North Dakota blacksmiths belong to an even greater tradition than their ethnic/religious base. They share company in the ancient endeavor of people to symbolize the universal.

Here then is art in everyday life, truly a gift of iron spirits.

NCV
Fargo
Autumn '82

x

THE SITE

A sequence of photographs telling a story on the prairie with time passing.

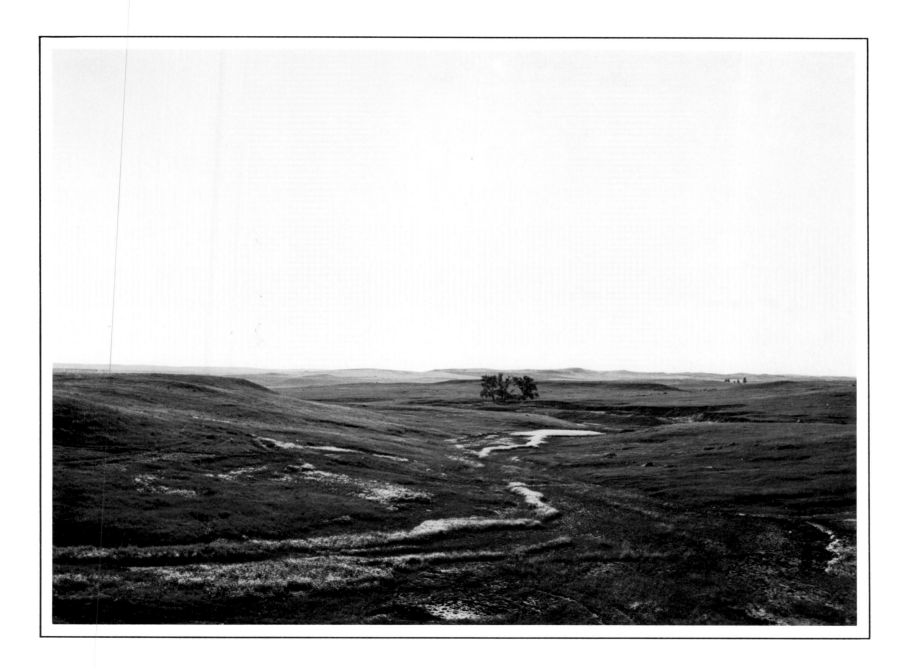

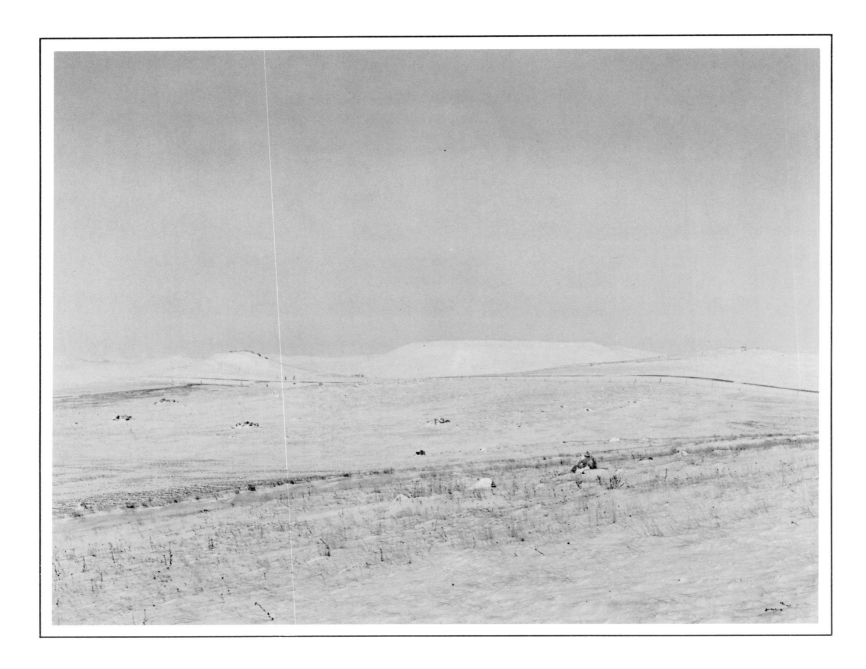

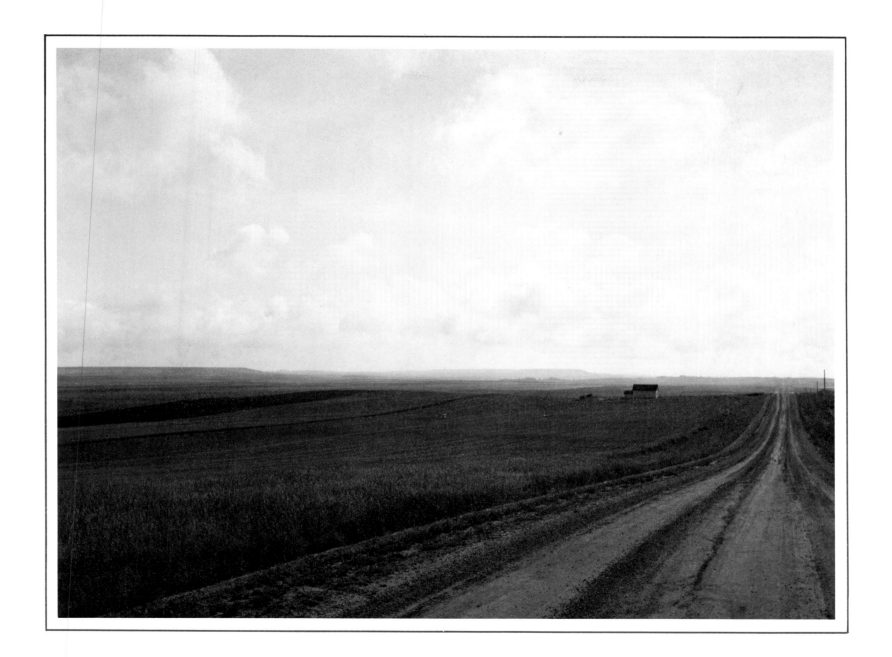

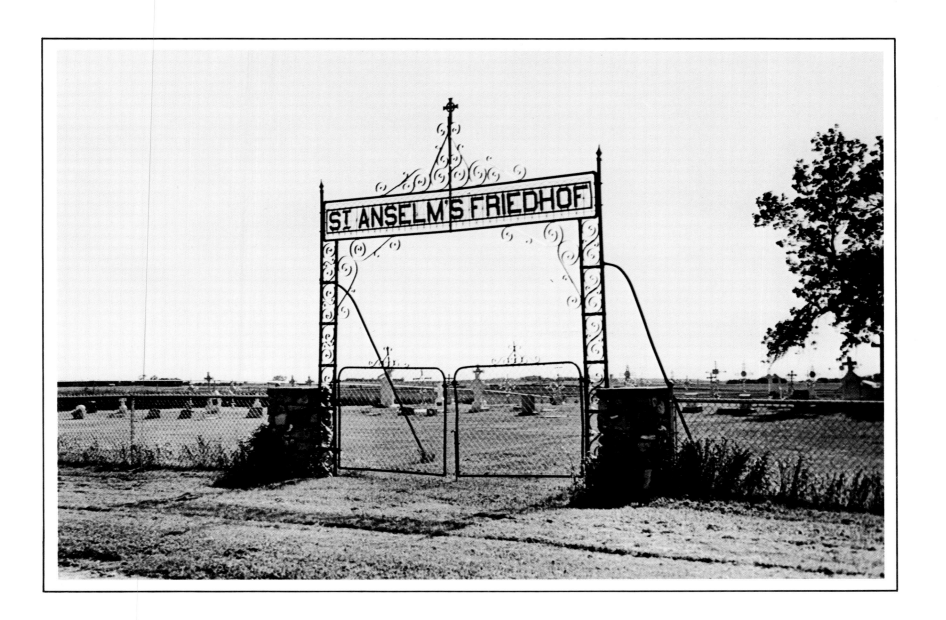

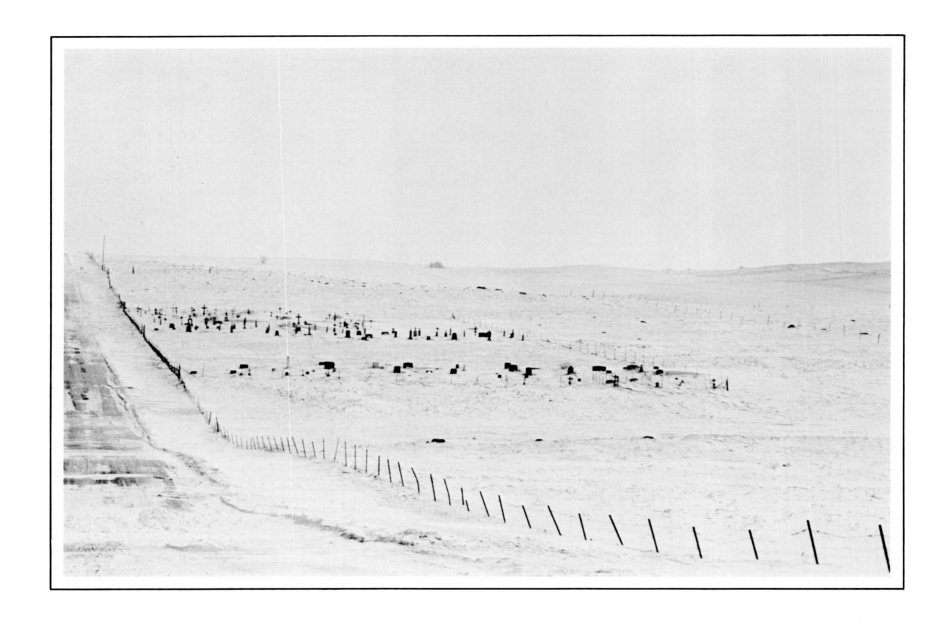

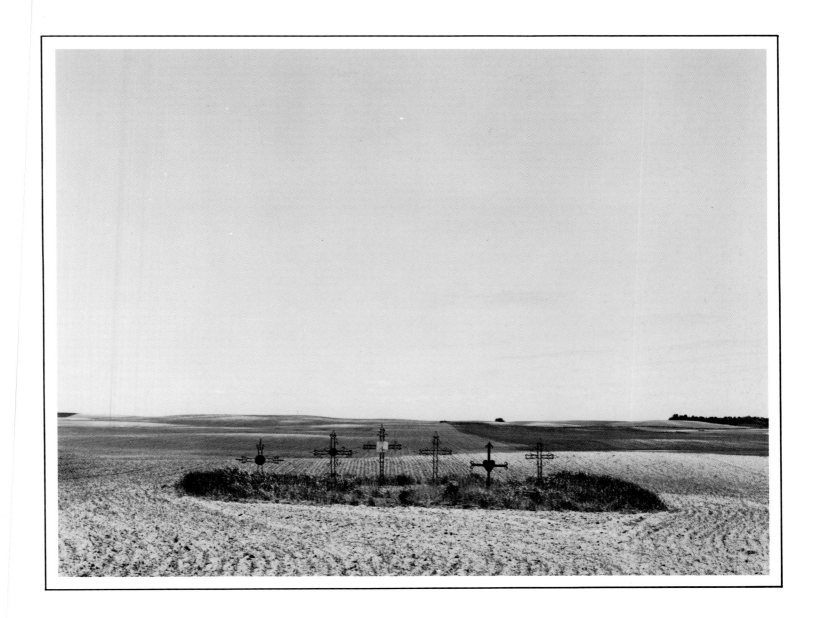

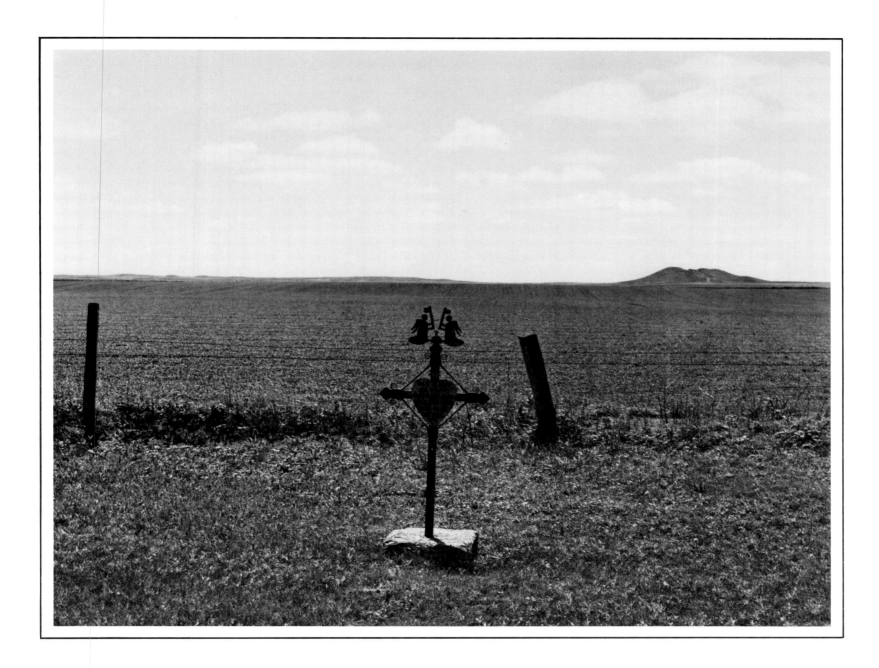

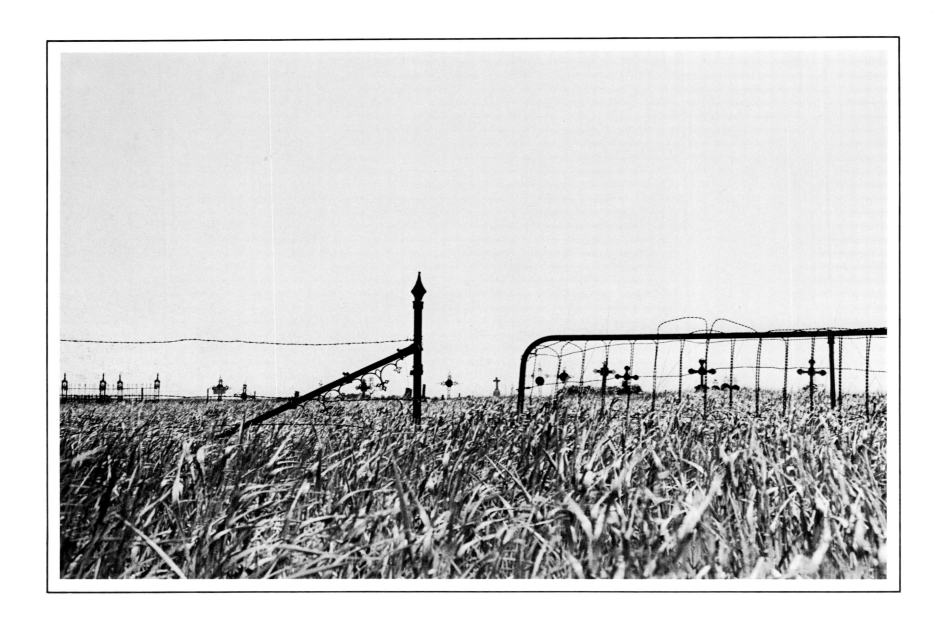

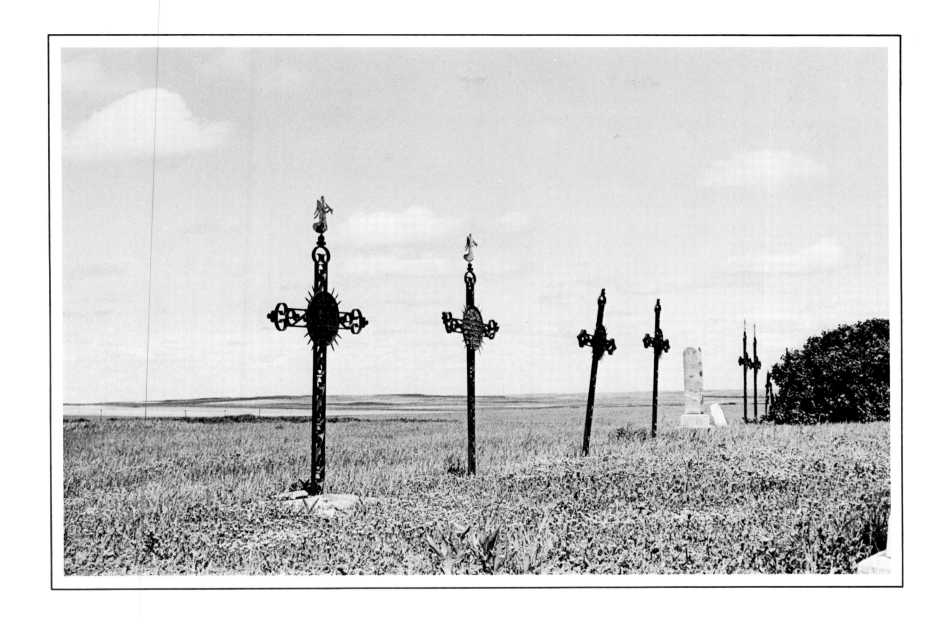

13

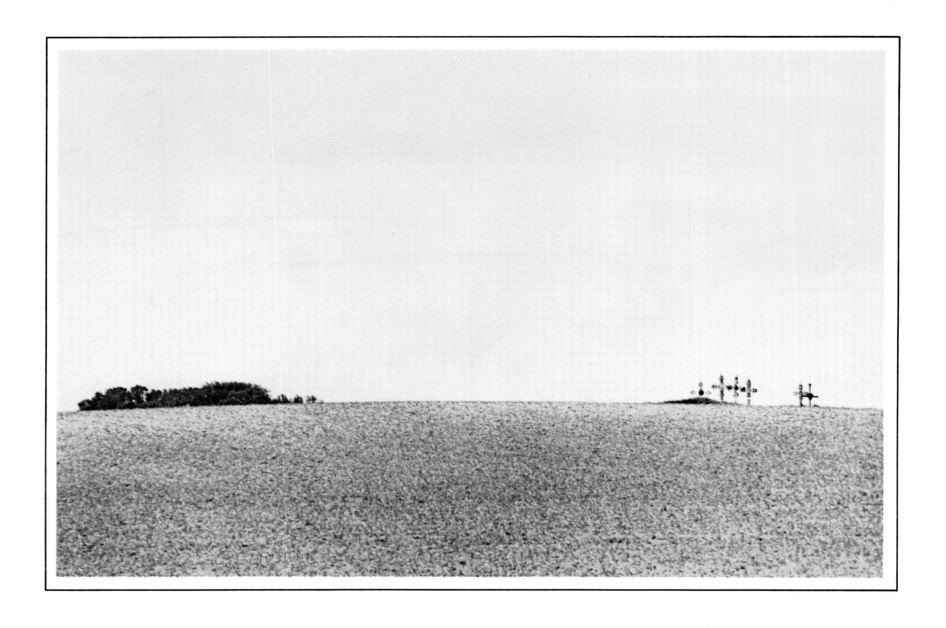

THE MEMORY

A personal story of growing up as a German Russian Catholic; community voices speaking about cemeteries and iron crosses. Photo note: the crosses in this section have yet to be matched to their makers.

PHYLLIS. I grew up during the 1940's on a farm in Morton County, North Dakota. My parents were German-Russians, as were most of the people in the community. My grandparents immigrated to North Dakota between 1885 and 1903 from Russia along with many of their friends and relatives. What does it mean, they were German-Russian? It means that the ancestors of these people migrated from Germany to Russia, and later generations migrated to America. The language and culture was basically German, but their one-hundred-year sojourn in Russia had its effects on their customs and way of life. As new settlers on the plains of North Dakota they used as many of their old, time-proven methods and principles as possible. Therefore it wasn't really a migration in the strict sense of the word, but more a transplanting. They built the same type of homes, formed and built the same type of churches, raised the same kinds of crops, gardens and animals, wore the same type of clothing, ate the same foods, raised and educated their children in the same manner, and kept the family unit intact. What worked and had been good enough for their parents and grandparents was certainly good enough for them.

For these reasons German-Russian assimilation into the American way of life did not come about quickly. The first generation born on American soil was torn between keeping up the family traditions and following the new American way of life. It could almost be called a time of cultural void, they didn't want to be what they were and they were not yet anything

else. If anything, they wanted to shrug off the old ways. There was a certain stigma attached to being a ''Roossian'', as they were often called. Because the majority of them went about their own business and didn't get involved in the running of the community, they were considered just a little bit backward. One must know, in order to understand this ''don't get involved'' policy, that in Russia it was better that they not be involved at all with the government. Each individual dorf or village in Russia was self-governing. They ran their own church the way they saw fit, and did not under any circumstances get involved with the Russian government affairs.

The world wars created difficult times for the German-Russians, particularly World War II. The Germans were already looked down upon, so can you imagine adding Russian to that . . . why that was two strikes against you! These people wanted only to be left alone to work their fields, raise their children, and go to church. But their ethnicity was a hindrance, they weren't allowed to . . . and so they became Americans. For these reasons many of the old traditions fell by the wayside to such a great degree that some have been lost completely. One of these traditions was the use of iron crosses as grave markers.

* * * * *

The handmade iron crosses are truly works of art in every sense of the word. Perhaps it is a bit difficult to imagine a blacksmith as an artist, but the word definitely applies to those who made them. Since I was a young girl the crosses have intrigued me. But it wasn't until after my college art classes that I really appreciated the talent of the makers of the iron crosses. There I was, studying the basic design forms that these blacksmiths had used in making the crosses, and most of them didn't even have an eighth grade education! Perhaps there is such a thing as inborn talent, the ability to know when it is right and when the lines produce a pleasing shape.

The German-Russians were a people who were not easily impressed, least of all with themselves. Perhaps therein lies one of the secrets of the beauty in the crosses. Their creation was done in a spontaneous nature . . . they used what was on hand . . . heated the iron and bent it around whatever was available in the blacksmith shop. I know the German-Russians too well to know that they didn't buy any special equipment when something already available worked just as well. They were frugal people and used absolutely everything that was usable. Nothing went to waste, be it food, clothing, wood, metal, an old piece of harness or whatever, everything had a use someplace. It was much more economical to have a marker made from available scrap iron than it was to buy a stone one. Besides, they could always trade a chicken, some eggs and milk for the blacksmith's work if they didn't have the ready cash. Also by relying on their local blacksmith they remained self-sufficient . . . they didn't have to go outside their group to get something they needed.

Whether the blacksmiths themselves thought that what they did was anything special or not I cannot say. It seems not to have held much importance to the family, or it was taken for granted just as musical ability, singing, fancy work, mechanics, or any one of a number of talents. There may have been many of these blacksmith-artisans but people don't remember them as anything but blacksmiths. To the neighbors living beside them, it wasn't a great or important thing to be doing, they were just the smiths who also happened to make grave crosses.

We would like to know and understand the people and their culture to know why — why did they stop using them? Why did one artisan use a doorknob as an ornament on that cross? Why are that man's designs always shaped the same? Why is that one letter always upside down? Why do most of the markers face east? In order to understand their culture , let us go back and spend some time with that little girl from Morton County.

I am seven . . . it is my first day of ''vacation school'' which is held at St. Joseph's Catholic Church. It's a soft, warm spring day and the countryside is a lush green, bursting with new growth. As my sister and I enter the churchyard, I glance at the grove adjacent to the church to see if the lilacs are in bloom. Seeing that there are big, plump splashes of lavender, I make a mental note to pick some before we go home for the day. You see the lilacs do kind of belong to us, because that's where our house stood before we had it moved to the farm . . . so it's all right to pick some. As we get closer to the church I see many familiar faces and I'm not scared anymore, not like I was on the first day of country school.

Vacation school is really school for religious instruction, held for two weeks each June, which the children from the parish families were required to attend. The day's schedule included Mass, studying the Catholic Catechism and Bible, singing, and preparation for First Holy Communion and Confirmation. Most of the children attended these classes for seven to ten years or until they went to high school in town, where classes were held weekly.

You see, ours is a country church, one of many that dot the North Dakota countryside. Our church is the center of our existence, the thing around which everything else revolved. Not that our own families aren't of greater importance than the church, they are, but our church is our first contact with the outside world, our social outlet as well as our guide to live by. During the week our lives revolve around working, playing, and learning, but always with thoughts about God and church. The Ten Commandments tell us it is wrong to swear and tell lies, they tell us to respect our parents and to worship God. These rules are taught to us as soon as we can talk and we learn to live by them. We learn that God is All Powerful, that He controls everything that happens to us. We learn to pray to Him for the things that we want, be it good weather, a new dress, or a tiger-

stripe kitty! Nothing was too insignificant in our minds. If we wanted it we prayed for it. Of course we didn't always have our prayers answered, but that too was a lesson to be learned. It wasn't always God's will that things work out as we wanted them. This type of upbringing resulted in a child with a conscience, one who knew right from wrong, and one who held a deep respect for those older and wiser. There was no doubt in my mind that I would be punished from above if I was disobedient, disrespectful and so on.

God touched our lives in some small way each and every day. He was always present and He knew what that little girl in Morton County was doing every minute. I was important enough to be noticed by God and I always tried to remember that fact. Mama and Papa only judged my actions by what they saw and heard, but God even knew what I was thinking! So I did the right things rather than suffer the pangs of guilt. So you see, vacation school was simply an extension of our religious training, the rules were already deeply ingrained in us.

When we arrive at church we enter quickly so that we're not late for Mass, which starts the day for us. Mass is a beautiful service, very solemn, very quiet, and a time to pray. The best thing about vacation school Masses is that we get to sing and say the altar prayers along with Father, and I love it! The Latin lyrics are so soft and pretty and sometimes Sister even lets us sing a German song! It's kind of different being in church without Mama and Papa because we can sit anywhere we want as long as it's towards the front. On Sundays the girls and women sit on the left side and the men and boys on the right side . . . I wonder how come? Another thing that's different is that Father talks just to us and we feel very special.

After Mass we all file down to the church basement where classes are held. It is dim and cool in the basement, and a host of

smells greet us as we enter, it's a combination of musky basement, incense, books, wood, and school lunch pails. Pews from the old church are arranged in a classroom fashion in three separate rooms. One is for First Communicants, one for Confirmants and one for those who have completed both. I make sure little sister is with me and we find our way to the First Communicant room.

The nuns who teach us are from the Parochial School in town. They come out every spring to hold vacation school for us. Sister greets us and asks our names and a little bit about each of us. Mama and Papa told me I have to take care of little sister and I ask if she can make her First Communion with me even if she is a year younger. Sister has to talk this over with Father before she can answer. We want so badly to do it together, sort of moral support I suppose, but Father Dominic said the rule stated she has to be seven. Little sister cries but she learns to accept the fact that rules are made to be kept and not broken, but she is allowed to attend the two weeks of classes with me. Sister gives us each our own Catechism and we study from it and become familiar with it.

Before lunch she says that because it is our first day and the weather is so nice she will take us on a tour of the church and cemetery after lunch. We are happy about this as we carry our lunch pails to the sunny east side of the church to have our noon meal. We sit on the soft, green grass to eat our bologna or chokecherry jelly sandwiches, a boiled egg, an orange or apple. We are all from different families but most of us have the same foods for lunch. I often wonder if our mothers get together on this! Sometimes a treat in one lunch pail such as halva, strudel, plachenda, bananas or candy will be shared by many.

After lunch Sister tells us to take someone else's hand and walk by twos . . . Of course I have little sister's hand so I don't need to find anyone else. First we go upstairs into church and say a prayer to our Guardian Angel. Sister cautions us to remember that we are in God's house and then she takes us up to the altar. We are awed. We have never been up there before. She lets us touch the gold engravings on the railing and climb the little stairs to the pulpit. It is magnificent!

After we leave the church we stop at Father Dominic's house to visit. He is our parish priest, a little man with a German accent, one of the truly good people. He's strict but in a kind and gentle way. We all like him and do our best to please him.

After that we start the long walk to the cemetery south of the church. As we cross the softball diamond we can see the iron crosses pointing skyward, looking like they are waving a greeting to us. As we walk closer we can see the stones huddled solidly in between the crosses giving the whole area the appearance of a town where someone lives.

Mama and Papa had brought us to the cemetery many times before and upon entering we always knelt at the big central cross and said some prayers. We did the same now. Sister cautions us not to walk on the graves but to stay to the paths in between. We walk around for awhile finding parents, grandparents, great-grandparents, uncles, aunts and others of our relatives and friends. There are lilac bushes and irises blooming on some of the graves but, of course, we don't pick them because they belong to the people in the graves. Just as we would never walk on the graves because it would be disrespectful to those who lay buried there. We walk around and read the names and look at the pictures on some of the stones before Sister tells us we can visit our special people.

Little sister and I go to Uncle Walter's and Aunt Rosie's graves. We know exactly where they are because we helped Mama and Papa clean them each year. Walter was Mama's brother, just a few weeks old when he died. His name is spelled out with black

tacks on a wooden cross. Some of the tacks are coming loose and we push them in again so that his name will always be on that cross. Rosie was Papa's little sister, she died when she was a little girl about our age. Grandpa had been unloading coal and backed the wagon over her legs not knowing that she was catching a ride on back. We feel so sorry for her but console ourselves with the fact that she wouldn't have been very happy without legs.

Then we go to Grandpa's grave, saving the best for last because we like to visit him. And it really is like a visit, we greet him as if he was alive and there. Grandpa died before we were born so we never got to know him as a living person. However we did know a lot about him from listening to Papa tell us different things he said and did. I always feel I have a direct line to Heaven because I know Grandpa is there helping me. He was a good man. Everyone said he died so young because he worked too hard helping others. For that reason I go to visit him and pray when I really want something special. Maybe that is silly but it certainly helps a little girl in need.

Grandpa has an iron cross grave marker which seems so much kinder than the cold stone markers on some of the other graves. It is made of iron that is shaped and curved to form an interesting design. I blur my eyes and squint to make some interesting pictures . . . the cross is almost a leaf and flower design and looks like it could have grown from the earth it is planted in. It blends with the bushes and grass, not contrasting with them as the others do. The stones are solidly there, I can't help but see them, whereas the iron crosses are almost spiritual. There, but not there. I think maybe that is really what they meant them to be, a spirit guarding over the loved ones. Grandpa's is curves and scrolls of metal with a circle in the center that has his name and dates on it. I touch the smooth, black curves of the cross and trace my finger over the raised letters that spell Grandpa's name . . . Athanasius Hertz . . . a

different name, but nice. I wonder how they make the letters so nicely formed out of something as hard as iron. One day I will find out. Sister said it is time to go and we wave good-by to Grandpa.

* * * * *

Many years have passed since that day at the cemetery and I have gone back to visit many times. It is always with a feeling of peace, a feeling of coming home that I go to visit. Only once, on a bitter, cold February day did I go there with dread . . . on that day we buried Papa. But on seeing that Grandpa, Grandma, Great-grandpa and Great-grandma were there I was comforted with the thought that really . . . Papa was coming home to be with his family. And my direct line to Heaven grew stronger . . . silly? Who is to say.

We go to visit and care for the graves several times a year and no family gathering is complete unless we visit the cemetery. After all, they are still a part of us. I always try to take rust or gold flowers because Papa liked those colors. Now you say what difference does that make when he's not here and doesn't know what color the flowers are? I feel that he does know, that there is a life after death. That's an important aspect of the spiritual life of the German-Russians. They believe that life does go on even after death.

Gottesacker and Friedhof were two terms used most frequently by German-Russians when referring to the cemetery. Friedhof means peaceyard or courtyard of peace. Gottesacker translated literally means God's acre or field. The words that they used describe how they felt about the cemetery. It was not simply a place to bury or be buried . . . it was a place to be at rest with God.

Phyllis Hertz Feser is a long-time advocate of the iron crosses and German Russian cultural heritage.

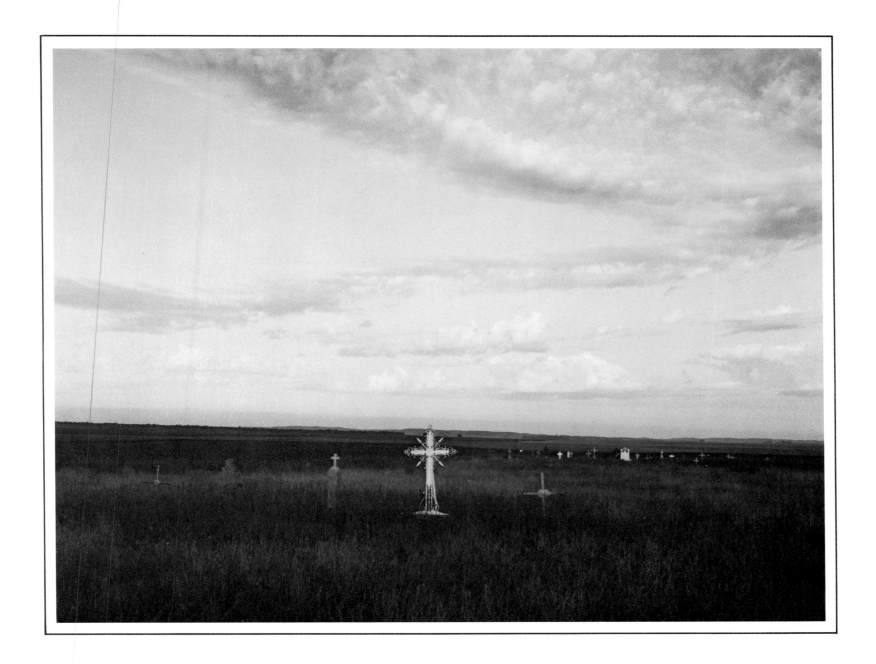

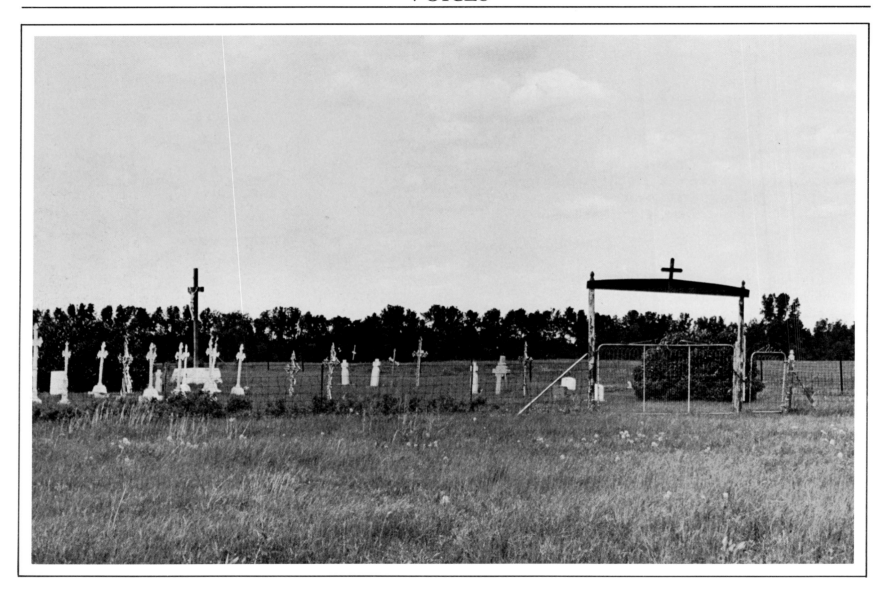

CAROLINE. I was a little girl and we lived right beside the cemetery them days. I remember that's all they had in that cemetery, was iron crosses. And in the spring of the year the people would go and paint their crosses if they needed it. Fix up their graves. We could go along in, we could help something, carry the weeds away or whatever there was. But we didn't dare to go in to play, that was a sacred place.

NICK. I know some people, my wife's got a cousin, years ago as a boy when he passed a graveyard, riding horseback at night, he rode all the horse was good for to get away from the graveyard. Afraid of the graveyard!

JOE. It brings back memories. I walk into them. I got a brother, he comes up here and we go out and drive to five, six of them cemeteries. You recall the old people that you know. Remember them. There's an attachment to the people. And that's what was you know. There's a certain thing there a stone doesn't do.

GEORGE. I thought a lot of things about it, imagined how everybody'd looked, how they would look by this time.

MARY. You walk around the cemetery, and you look at them, it gives you a deep thought. How at that time they had it that way. It seems to be more of a deeper religion. At that time, that meant so much to them. It makes a person feel like he'd like to know who made these.

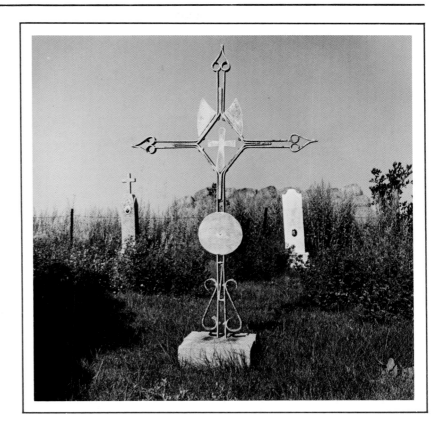

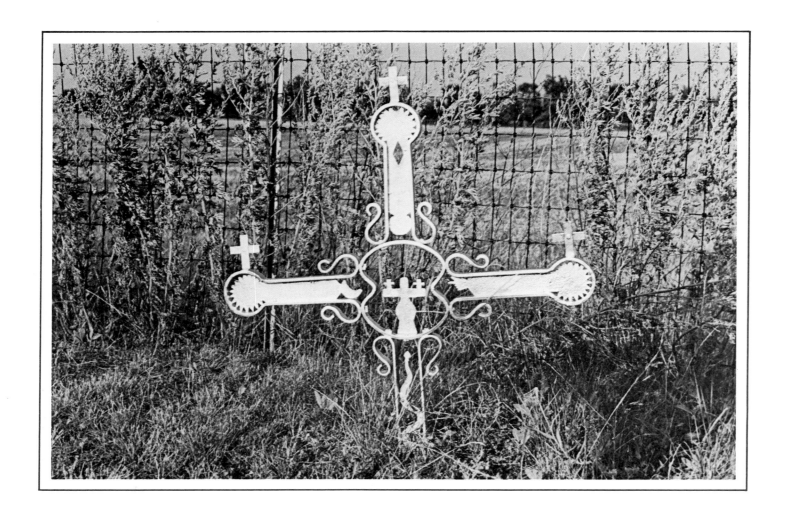

JOE. Everybody was closer at that time.

CAROLINE. I think we should talk more about those days,
then we wouldn't forget so bad.

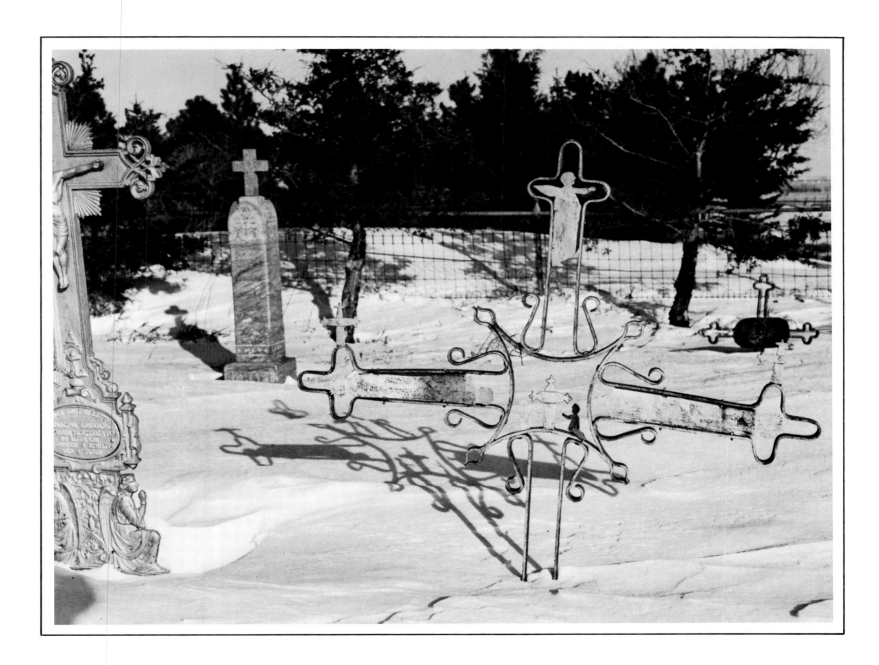

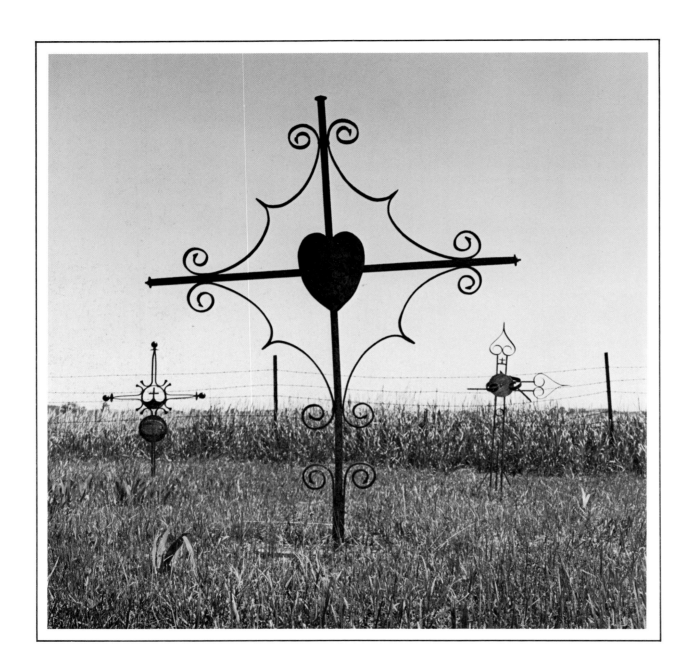

JOHN. There's nobody takes care of it no more. The cows keep it clean.

MIKE. That should be kept up because it's a burial ground.

NICK. The fire went over this and burned all them crosses, back in 1918 in the fall. Took the whole country. The iron crosses they survived, and the wooden ones burned off. Some of them iron crosses they were all scorched. People come and they painted them. Some of them still have no name on.

TILLIE. You'd be surprised, there's lots of people come to visit this graveyard in the summertime. It's not neglected. There's always people visiting the year out.

ROSE. Some of our friends, we've talked about these crosses and we think it's really nice. More or less the beauty of it. I kinda wish it would come back.

BALZER. The cemetery looks pretty nice now. They burned all the weeds out and painted crosses all.

ROSE. Most people don't talk too much about cemeteries, the only time is when it's time to come and clean, I mean that's the time you really recognize and see things. It's not forgotten. I think the people look up more, more so than your stone. I guess everybody kinda thinks they're outdated.

CAROLINE. It was nice. Those crosses were nice when you walked into a cemetery. I enjoy going more than anything. You think of the years when your parents were still here, and your grandparents you know. When they're gone, they hurt. And sometimes when you go there, you feel so much better.

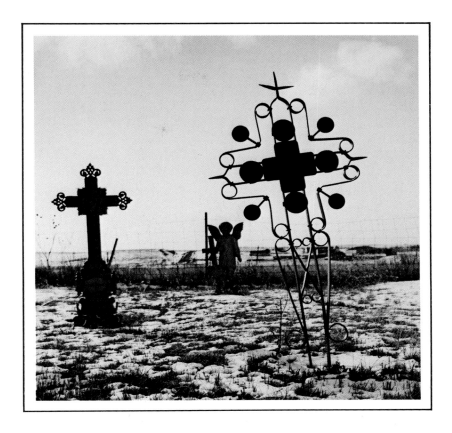

JOSEPHINE. Like these iron ones now, a man done them all just with his hands. Gives you a different feeling because you knew the man, that did them, and you knew how hard he worked at it, and how he did it.

CLEM. I walked by many years, never looked at one. You know, because if you don't stop to realize the quality of work these people put in. I don't think they really pay much attention to them. I don't think the average person thought more than I did until I looked at them.

TONY. Some people are more interested in somethin like that than others. When other people come and admire them, maybe then we get interested. We thought it was something old-fashioned.

FRED. They originated in Russia. The old-fashioned wagon makers they called them. They brought that from Russia. A wagon maker is a, he was a blacksmith.

TILLIE. From the way old timers, that's what they done over there, so that's what they done over here.

JOE. Each one came from a different area in the old country so you could see maybe the change in the design.

WALTER. Each man had his own pattern, he had to be distinguished all by himself.

GARY. Why would a blacksmith at that time tackle something as difficult as that? Like from creation to creation. They all had their own style, everyone is made different, and there aren't two the same.

ROSE. I think it's marvelous, really. You know there's a lot of art in there, a lot of work.

PIUS. We'd go there sometimes, the blacksmith, and look at what they're doing. They always had a few ready-made ones, they made them before for sale, they even had them displayed sometimes. There was a drug store, and they put them in there as samples. One or two set there to look at.

FRED. He was an important man, with his schmidt coal, and his bellows, iron anvil, a few handmade iron tongs.

JOHN. Think next time I go out there, I'm gonna take a look at that thing again. Kinda raised my interest.

GERTRUDE. They're just a beautiful thing! With just a little scrap iron.

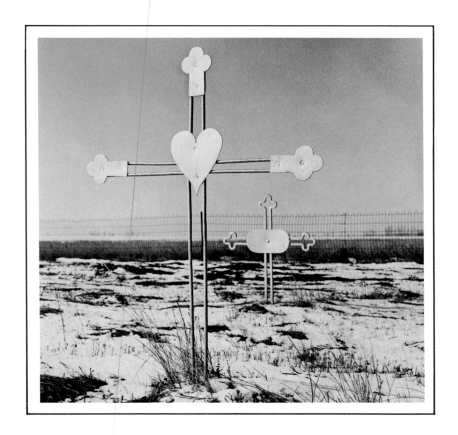 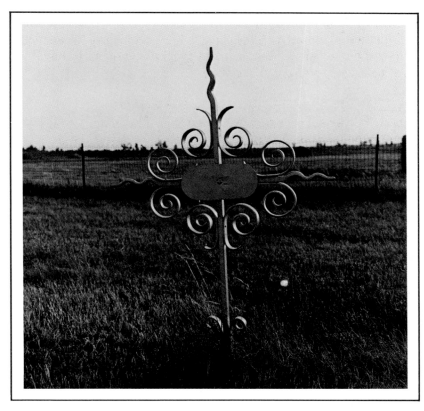

TONY. They must have liked them. They were not just satisfied probably with the plain cross. They wanted something fancier, more beautiful, something different. It's probably just the way people liked to make it, just like with everything else, like crocheting or anything.

GEORGE. I imagine the reason was probably that it was the easiest thing they could get to work with.

TONY. Maybe the stones were kinda expensive, compared to blacksmith work, that was real cheap in those days. Or maybe they were hard to get.

GERTRUDE. Like I say, it was just style. The new thing come out with these stones, everybody just fell for that.

PIUS. These fellas come along selling tombstones. They began to go into tombstones then.

TILLIE. Well with this new generation, then there was something new going on. As things went on then they started coming out with something new again. This is the way it went on.

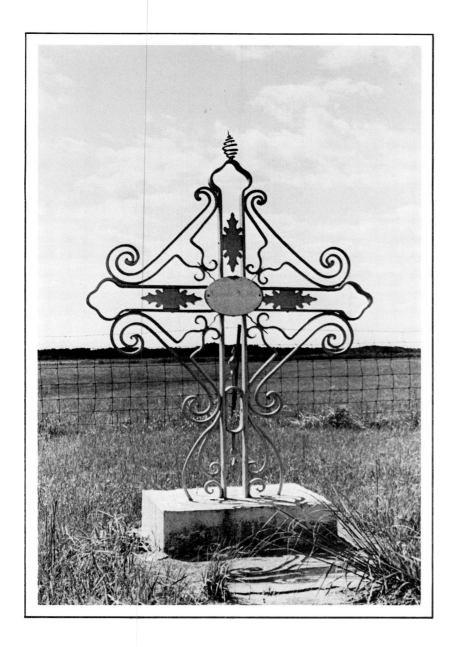

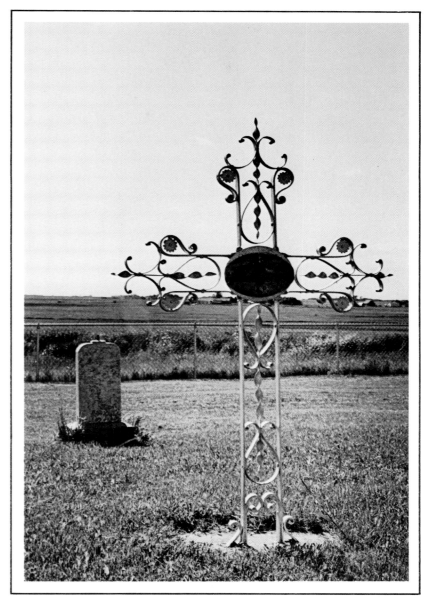

JACK. They're out there now, but they're all worn out aren't they?

BEDE. Those old crosses, I doubt whether there's anybody around here that has any interest in them. Those people are gone, and their relatives have forgotten all about it.

MIKE. That's water under the bridge now. It's all obsolete.

CLEM. People moved away, nobody around to take care of them.

GERTRUDE. There was a lot of them over there. And in time they just, they kinda fall over, nobody's done anything, so they pushed them to the side of the fence and what happened to them we don't know. And so a lot of them were over there that aren't there now.

TONY. You get so used to that cemetery you don't hardly see it any more.

JOE. I think they're gonna go all out. They don't want that stuff. They'll have to pass a law. They wanna eliminate all that, and just keep like a military cemetery.

GEORGE. What is there? It's a big remembrance, you get a plate on there, have a marker, who died, what more do you want? It's a marker. They're just too much bother, they wanna get away from that. At one time you know nobody cared about these things, antiques. Who would care about the old, new stuff is what they cared for.

JOE. At that time you know we weren't interested in stuff like that, that was just some old iron anyways. That's what we thought at least. But now as getting older, it's getting more valuable.

MAGDALENE. The cross always means more to me than just that marker.

FRED. I would say it was just to identify them that they were Catholics and the cross is a symbol.

ANN. The cross more or less represents Christ on there, the love of Christ, more than just a little headstone.

FRED. We have a different way in approaching religion. We all have different ways. Now it's marble, marble, marble. You know, monuments. It will just mean that some people will remember another age. The crosses are a symbol of another age.

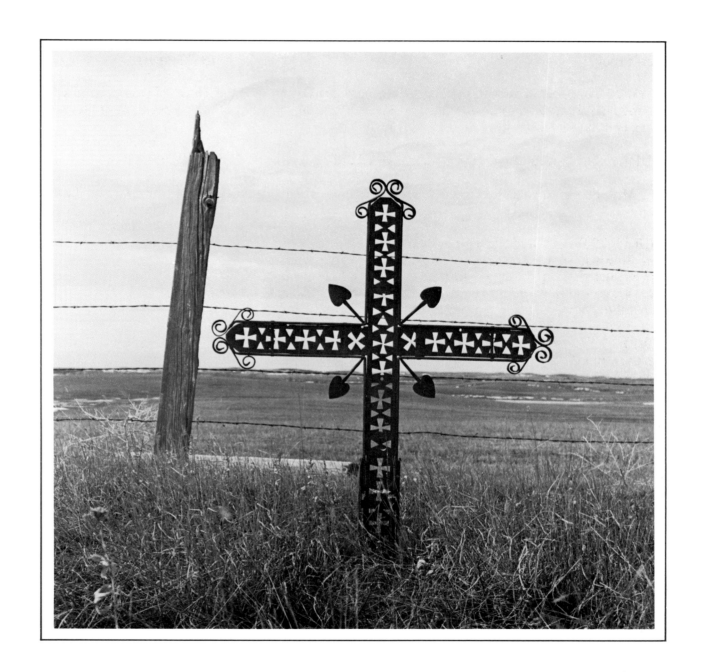

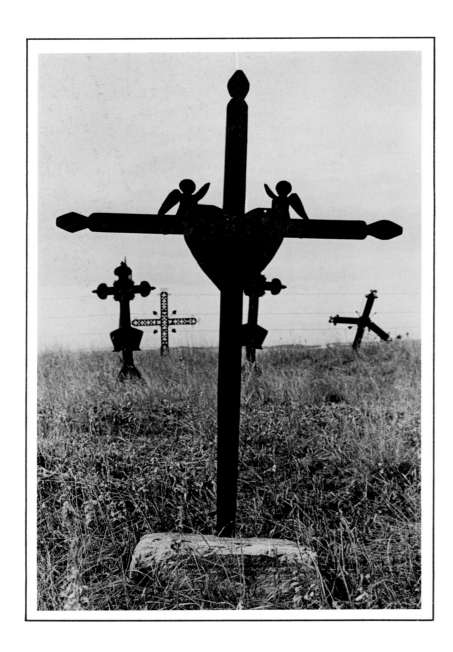

ELIZABETH. It's a holy angel. She was young yet when she passed away, and then they usually put an angel on. The angels, that means a saint, that she's a saint.

FRANK. Something to last. Some of them people that come over here, they wanted everything to last, everything's gonna live forever.

FRED. It was something hard, something that would be permanent.

TONY. To us it was just the natural thing, you don't think about it. They were there.

PETE. Just decorations I spose.

EVA. To me it means the same thing now as now they have the style with those stones.

TERESA. I think it means just as much as those stones. All that time they have these, and now they have these.

KATIE. It's just a sign where your sister or your brother or your mother is buried, and they want that for remembrance. That's why they have them crosses on there. They have signs where their dead person is. They can't do nothing to help their soul after it's passed away. A wooden cross, or iron, that doesn't help that soul for nothing. It's just so they have a sign there for their dead person.

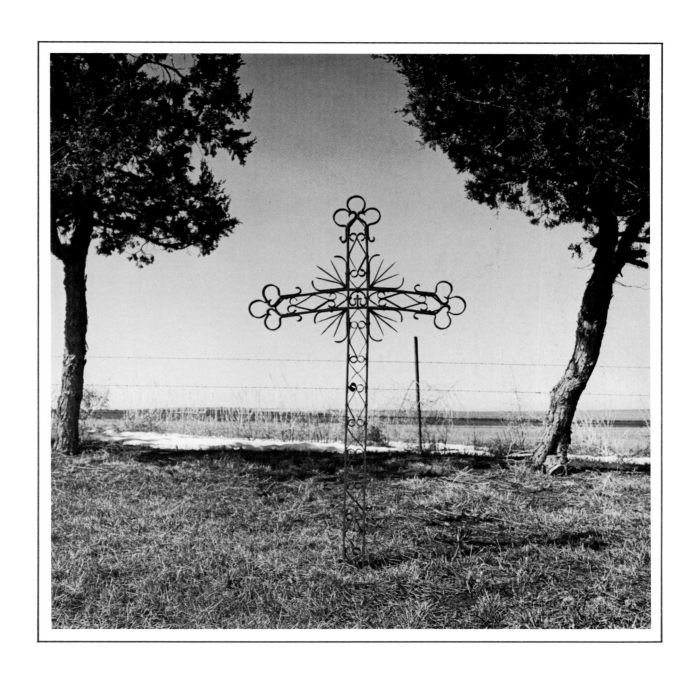

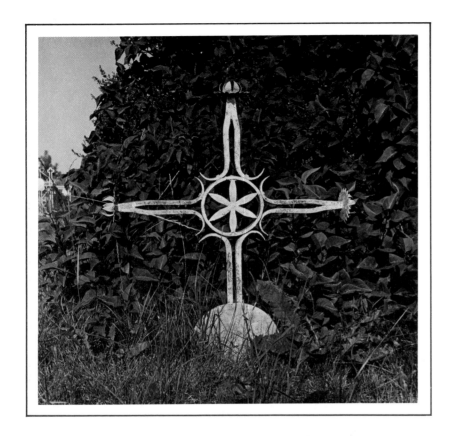 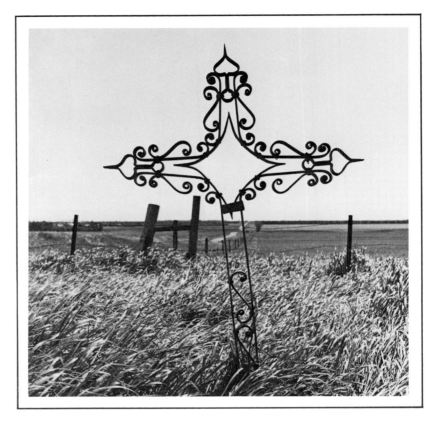

TILLIE. What shall we do about it, they're good yet. Sometimes you want to know who all is buried there. It reminds you of your relations all this and that then.

CAROLINE. In years back the older people thought they represented their faith, that they believe in God. I think they go way back. It took an old blacksmith to make them.

ROSE. I think they're beautiful. Really they are. There's somethin about it. I think it looks more spiritual like. It represents more of the dead. You know like Jesus died on the cross.

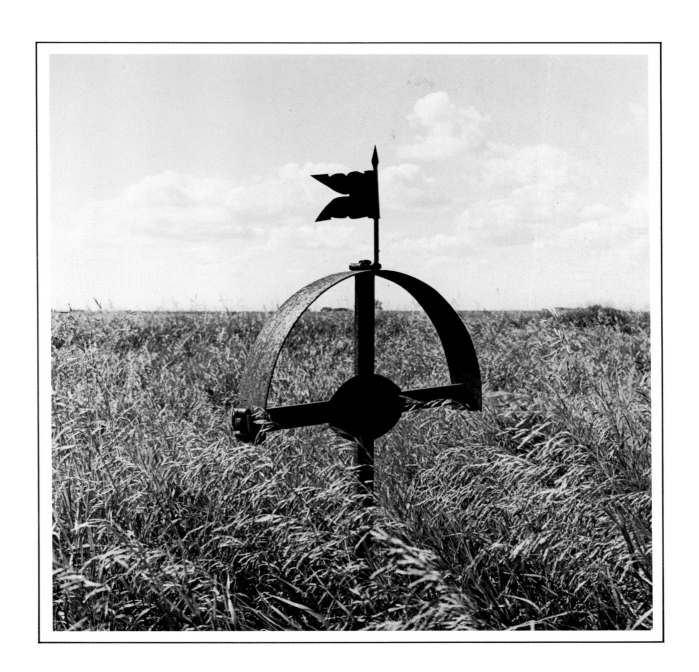

THE RITE

Funeral days at the time the iron cross tradition was practiced.

ANN. In the eyes of God, it didn't make any difference if you were rich or poor or good looking, they'll treat you alike, everybody has to go through that. It'll be all the same in the eyes of God.

TILLIE. Your funeral days, they were supposed to be the happy ones. Cause after all you go back to the other world, and you were supposed to face our Lord, you're supposed to be happy. It is happy for the soul.

JOE. The dead person you know. They didn't have no mortuaries. The wake was at the house. Usually it was two evenings where the rosaries were prayed.

ELIZABETH. My grandmother died in the house where I was born and raised. My mother's uncle's wife and my grandmother's relatives are the ones that bathed her after she passed away and dressed her.

At that time embalming was not a law yet. They had ice tubs under the coffin. And they put her in the coffin. They had her laying on the floor with a white sheet.

She was laying there. The people from town that knew her, some walked out there, some of them came with the old cars, some of them came with the buggies, and they stayed all night long, twenty-four hours.

With the wake at night they prayed the rosary, they prayed certain litanies. The leader, she lit the candles. And as the friends, the neighbors and the relatives came, there was a little bottle of holy water, everybody kinda give the body a little bit of holy water with a sign of the cross or whichever they felt. And then the rosary was prayed. And the litany. Many times the Litany to All Saints.

Everybody knelt. I remember. Just wall to wall, people kneeling. In the home. And sometimes coffee was brewed, the big homemade bread come out, the ones that stayed overnight would have a little lunch, and they'd pray the rosary until the next morning when the Mass was ready.

TILLIE. The religion was more work at that time as it's nowadays.

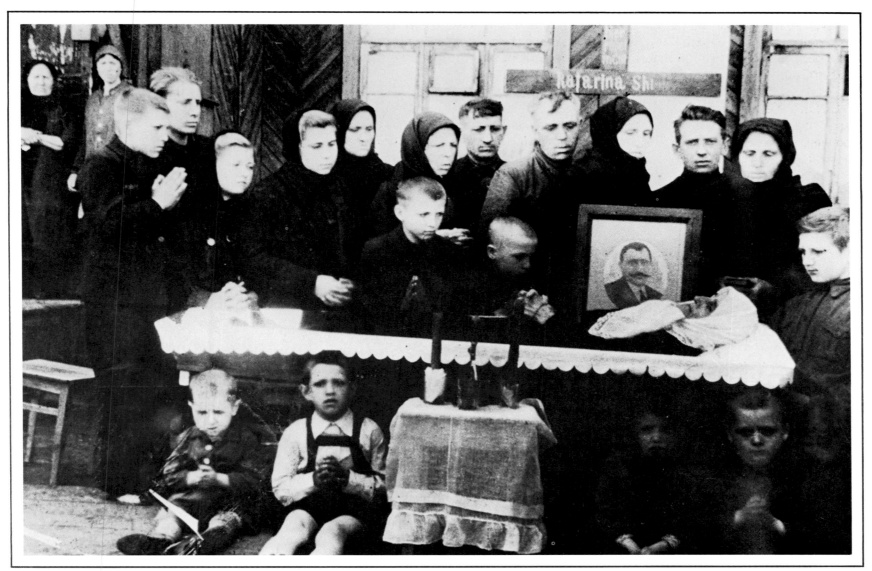

Funeral wake in the old country akin to those held in North Dakota homes

PETER. My dad for example, he died out on that farm in 1935, and we had what we called an undertaker in town here. So we had to come and get him, he didn't have a car. He just had his little satchel with embalming fluids and a portable embalming table, a wooden one. Laid my dad on the table, embalmed him out there, and dressed him. And then he left, we didn't see him after that.

We came in with our truck. The undertaker parlor at that time, they had those three or four wooden caskets on shelves on the wall. So we picked one out, put it on our truck, took it to the farm.

It was the night after, me and my brothers we laid him into the casket.

ELIZABETH. My father made coffins for small children out of pinewood. Most of them were painted white or light blue. And my mother made little white pillows and sheets for the inside.

SIGMUND. Ya, they didn't buy them high-priced coffins, they built the wood ones, had some carpenter build them.

ROSE. I wouldn't wanna go back to the wooden coffins like they made then. Of course I guess there's no difference actually, but it's just the idea you feel like you're in a safer place in the casket that they've got now.

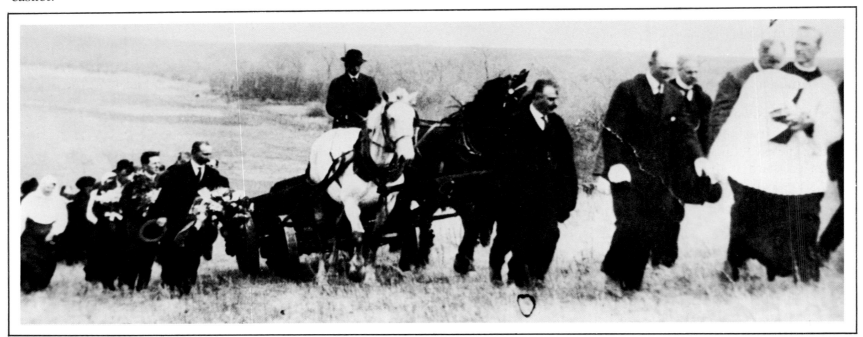

Funeral procession, central North Dakota, c. 1900. Courtesy of the State Historical Society of North Dakota.

JOE. Then of course usually it was hauled by either a sleigh or a wagon.

ELIZABETH. Most of the time they had two horses on there, nicest horses they had, had to be nicely cleaned, curried. And then that coffin was put on the back of that buggy and they led the procession all the way to the church.

PETER. Usually you took white horses. They looked more dignified I spose.

ELIZABETH. Then of course there was a Requiem High Mass. And then they had the singing, which was Latin in those days. After that funeral Mass, then the body was taken out on this buggy again and they led the procession. The priest and the Mass servers followed with the cross, and with the incense. Sometimes they had a candle. They walked to the cemetery.

And as everybody walked, the rosary was prayed. All the way, from the minute they started out, to the grave.

TILLIE. Funeral processions, I think they were more interesting than what they are now. Cause they were buried sadder than now. Now it's a lift, they lifted it all, for the people so it isn't so hard. In the earlier days it was much harder on the people the way they were buried.

CAROLINE. They were long. That I remember. And there were more prayers in the cemetery. And more singing. Nowadays you know there is no singing. Which I think is okay because the singing kinda hits you. And you're hurt enough.

WENDELIN. When my dad passed away in forty-one, they picked four guys, and they dug the grave by hand, with shovels.

JOE. I remember when those graves were dug in winter they had to haul coal on top, light a fire maybe in the morning and leave it til the evening, to thaw out the ground. And chisel them out you might say. But they did it! Everybody was buried at that time.

PETER. We just set our dad alongside the grave. And when the priest was all done with the blessing and so on, with straps they lowered it into a rough box.

WENDELIN. Them days, they let the body down while the people were there. They had the cover and they put it on your coffin.

And when that was done, then the first thing they did is, the priest took a shovel with dirt, and he made the sign of the cross, you know like you sprinkle holy water, he sprinkled the first shovel of dirt. And that rattled down there, boy I tell ya, that went through the people. That was hard, hard, hard I tell ya. That's the way they used to bury people. That dirt rattled you know! Boy I tell you, that sent shivers.

Then the choir starts singing Das Schicksal. Then I tell you when they sang that, they start singing it, oh, the tears were coming, oh.

ELIZABETH. It was a tremendous meaning, because it said 'do not cry for me, my soul is taken care of.'

Das Schicksal

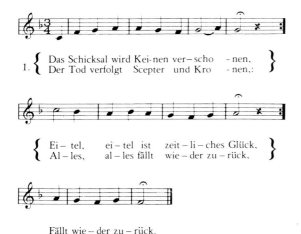

Das Schicksal wird Kei-nen ver-scho - nen,
Der Tod verfolgt Scepter und Kro - nen,:

Ei - tel, ei - tel ist zeit - li – ches Glück,
Al – les, al – les fällt wie – der zu – rück,

Fällt wie – der zu – rück.

*From the Catholic Song and
Prayer Book, B.H.K. Hellebusch
(Benziger Brothers, New York,
69th edition).
Translated by Phyllis Hertz Feser
and Armand Bauer.*

Das Schicksal wird Keinen verschonen,
Der Tod verfolgt Scepter und Kronen,
Eitel, eitel ist zeitliches Glück,
Alles, alles fällt wieder zurück,
Fällt wieder zurück.

Der Leib, von der Erde genommen,
Kehrt dorthin woher er gekommen,
Reichthum, Schönheit, Witz, glänzende Macht,
Alles decket die ewige Nacht,
Die ewige Nacht.

Auch dich wird der Tod noch abfordern,
Auch du wirst im Grabe vermodern,
Heute war die Reihe an mir,
Morgen ist sie vielleicht auch an dir,
Vielleicht auch an dir.

Jetzt wird mich die Erde bedecken,
Bis mich die Posaunen aufwecken,
Ich erwarte das letzte Gericht,
Und ich hoffe auf's ewige Licht,
Auf's ewige Licht.

Ich bleibe nicht ewig im Staube,
Das lehrt mich der heilige Glaube,
Denn die Seele vereinigt sich,
Mit dem Leibe, wie glücklich bin ich,
Wie glücklich bin ich.

Was weinet ihr, Freunde und Brüder?
Wir sehen einander ja wieder,
An dem Tage des jüngsten Gericht's,
Fürchtet Gott nur und fürchtet sonst nichts,
Und fürchtet sonst nichts.

Die Tränen sind Zeichen der Liebe,
Doch sind sie natürliche Triebe,
Nur um Eines, um Eines bitt'ich,
Betet täglich, ach betet für mich!
Ach, betet für mich.

A fate from which no one is spared,
Death comes to all, brings down staff and cross,
Joys of earthly life are but fleeting,
All, all souls return to their maker,
Return to their maker.

The body returns to the earth,
The earth from which it had come,
Riches, beauty, wit, shining strength,
These all pass into everlasting darkness,
Into everlasting darkness.

Death also will be demanded of you,
You also must molder in the grave,
This day it was my turn,
Tomorrow perhaps it will be yours,
Perhaps it will be yours.

Now earth will be my cover,
Until the trumpets awaken me,
I await the Last Judgment,
And I hope for everlasting light,
For everlasting light.

I will not remain dust forever,
This is taught me by Holy Writ,
For the soul is again united,
Body and soul united, how happy I am,
How happy I am.

Why are you weeping, friends and brothers?
Surely we'll see each other again,
On the great day of the Last Judgment,
So fear only God's wrath and fear nothing more,
And fear nothing more.

The tears you've shed are only signs of love,
Though sorrow is a normal feeling,
Only one thing, only one thing I ask,
Pray for me daily, o pray for me!
O pray for me.

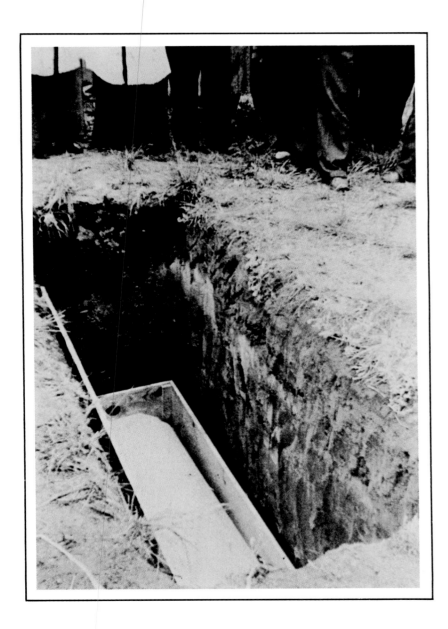

WENDELIN. The men were right there with a shovel. Then they start covering up the grave. And they worked, they were going.

PETER. They just shoveled like crazy. It just about broke your heart, all that dirt going to that wooden coffin.

TILLIE. When we buried somebody out there, the people never left the cemetery til all the grave was covered up. Even if it was in the middle of winter. Them days you stood around there and they shoveled the ground and everything. That's when really everything broke down you know.

WENDELIN. And then other guys took over, and kept on covering. They scraped it up and heaved it up. And when it was heaved up, then everybody left the cemetery.

THE SMITHS

Voices of family, friends and community remembering the cross makers, accompanied by examples of their work; notes on cross construction.

SCHNEIDER FAMILY

Three generations of cross makers.
Jacob, grandfather (1852-1934)
Deport (Tibertius), father (1877-1941)
Jake, son (1902-1961)
Louis, son (Born 1901)

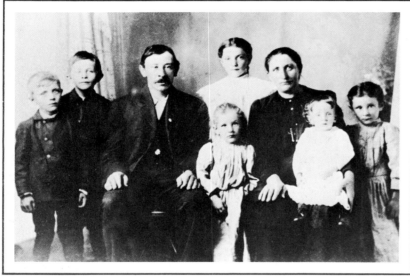

Deport and Rose Schneider family; sons Jake, far left, and Louis, second from left

LOUIS. Dad and grandfather, they come together from the Ukraine, the Odessa area. My grandfather learned others the trade for three meals a day and a little cigarette money. No wages. He was a rough man. Grandfather stayed with me til he died. He was a good blacksmith. He made his own cross four or five years before he died.

I watched my dad when I was a kid. It gives you ideas. A blacksmith thinks a little different than anybody else. A blacksmith makes everything up himself. It's pretty much by guess.

ANGELINE, Jake's wife. Louis, Jake and Deport worked together. Louis is the oldest one left now. He can tell you more than I can.

LOUIS. Ya, I've been shoeing horses since I was fourteen years old, started in my dad's shop. Sixteen, seventeen, I was about a full-fledged blacksmith and I learned it from one of the best there was. My dad was awful slow, but sure. It had to be just so or he wouldn't let it out of the shop.

I was awful powerful when I was young, so was my dad and so was my grandfather. Nothing come in my shop that I couldn't fix or weld. Nothing was too hard. A cross wasn't any more than a plowshare. It's awful good to know the trade. There isn't a day when it couldn't be used. I had so much iron! Piled up like a haystack. I used a lot of it. The coal came from Aberdeen, two ton at a time. I used to buy it for a dollar thirty-five cents a hundred. Now it costs as high as twelve, sixteen dollars a hundred pounds. And borax from the stores, 20 Mule Team, there was only one brand.

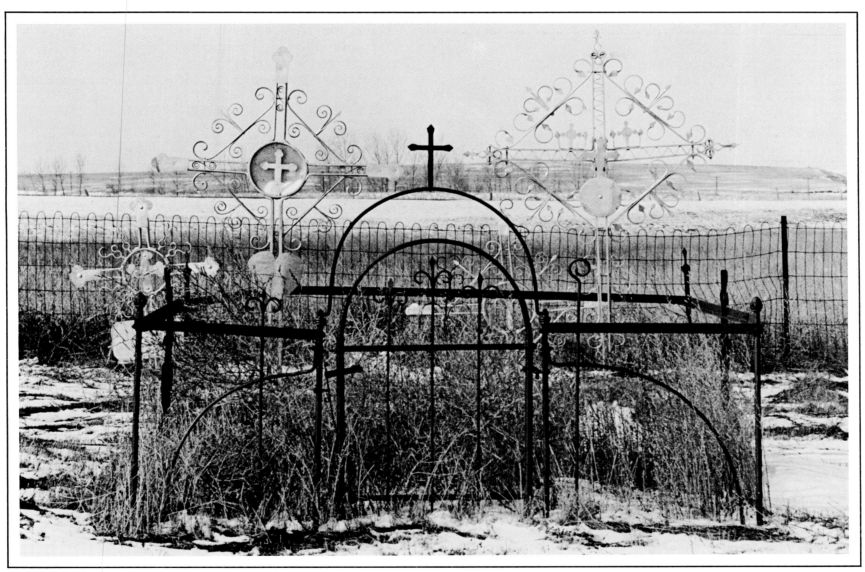

Deport Schneider, cross maker

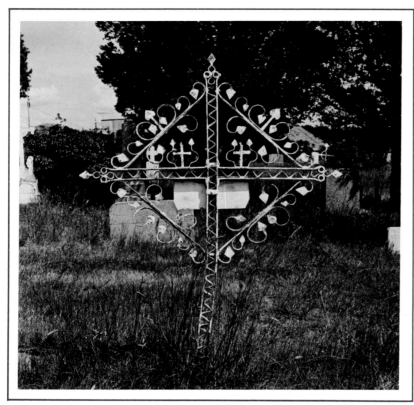

Louis Snider, cross maker; Black cross

Made crosses for the Indians, that's how I got started. Jim Black got the first one I made in my shop. I'll never forget that one! Some cattle got in there and bent the iron. I like that one the best.

You could finish one in a week easy if you was only a cross maker and nothing else. But with me, some of them I worked two months on, not steady, maybe an hour a day. Because I had too much other stuff to get out, you know. Very seldom you worked a whole day on a cross. In the wintertime I had the time to do more crosses.

Made the main cross part first, this was buggy tire. If you build one, you think of all kinds of designs. Lot of times you lay there and think at night how you're gonna dress it up. That just comes to ya you know, the looks.

I made the parts, put them together later. Mine had about thirty pieces or more to them. I made everything smooth with a hammer. I never used a hacksaw on one of them.
My brother's crosses made from old wagon wheels.
My iron work was lighter than his. He started when he was about thirty years old.

WENDELIN. His brother was married to my sister. He had the blacksmith shop. Jake said he was gonna make one for my dad because he was a relative and had made one for my grandma.

ANGELINE. Ya, it seems to me I was along with when he took it up. Just put it in the trunk of the car. We set them up, I helped him. He'd put it in cement. He had to dig a hole big enough to put it in and then fill it in around and that's it. They're all standing up yet.

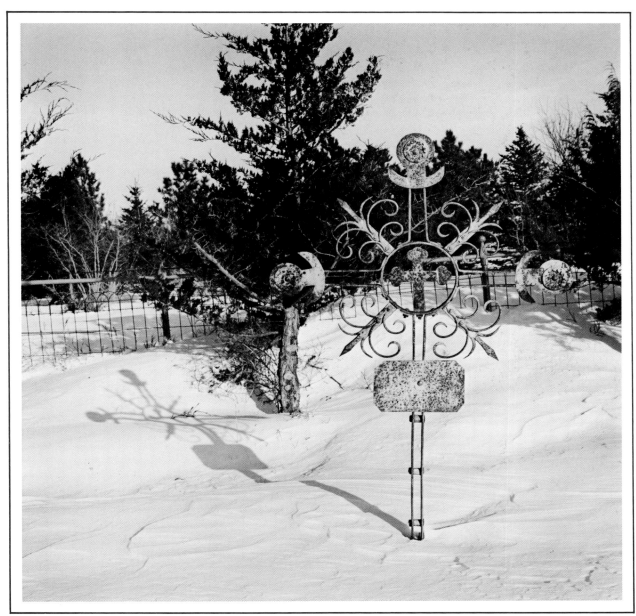

Deport Schneider, cross maker

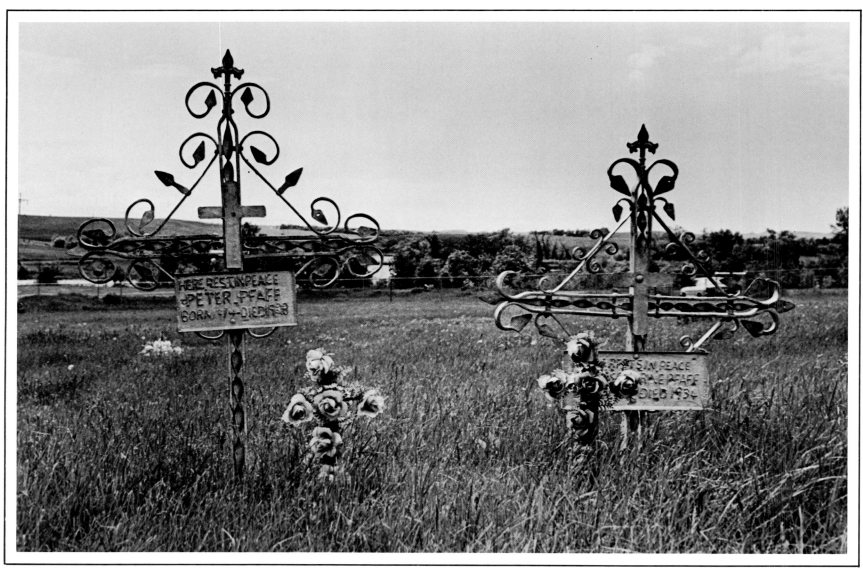

Jake Schneider, cross maker

WENDELIN. Well I guess if you had the iron and if you're a blacksmith and would have the pattern, you'd probably make one.

LOUIS. The work, it looks a little similar, but the styles, you change the styles on every cross ya might say. I think of the ones my dad made. No two were alike, every one was a little different.

ANGELINE. Jake's made some that are all with leaves, like leaves on a tree pretty near.

I always had to put the plaque on. I had to carve the names on a piece of wood. Had to put them on backwards and with a jackknife carve them out so it'd be deep. He'd put kind of a frame around it and then he'd melt the aluminum and pour it on there. It dried up and the names would be filled up. And then we'd paint them. We worked together. That's what made it easy, the teamwork.

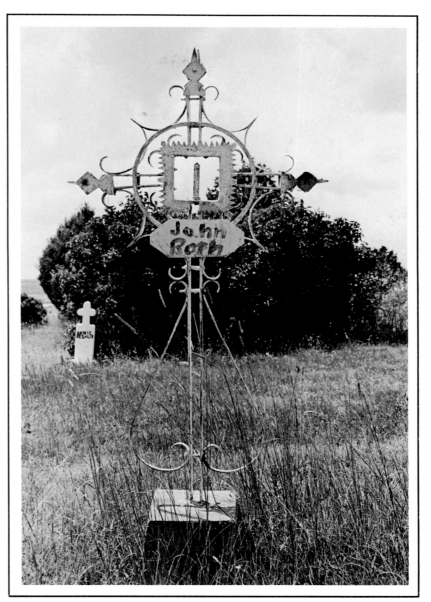

Louis Snider, cross maker

55

Louis Snider, cross maker

LOUIS. They were painted real nice. Some of them white, some black.

ANGELINE. It was interesting work you know. We used to talk a lot about it. I know he enjoyed making them because he could just wile his hours away, sometimes work til after twelve o'clock at night. Oh he loved it, with the crosses there.

But we couldn't make a living from it alone. You had to go out and get something else. I think he charged twenty dollars at the beginning, twenty-five at the last. A lot of people maybe got them because tombstones were so high. It's cheaper. And a cross like that, I like them better than a stone.

LOUIS. All kinds of tombstones, but the iron cross has still got it beat.

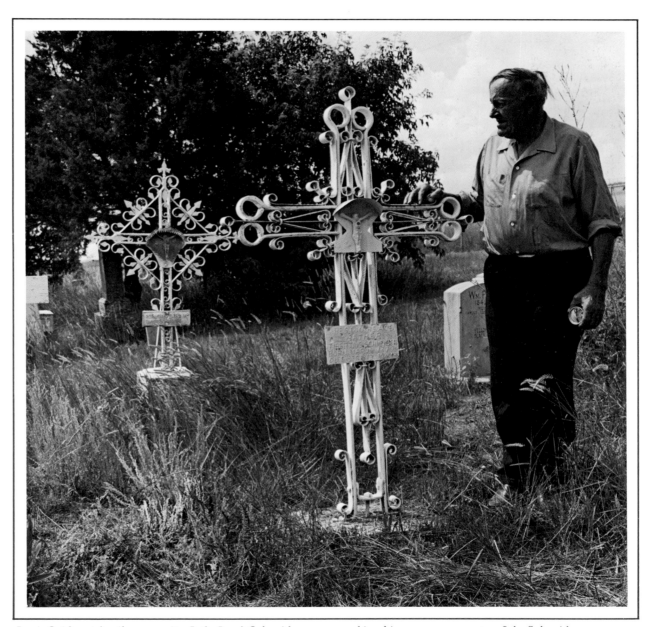

Louis Snider at family grave site. Left, Jacob Schneider cross marking his own grave; center, Jake Schneider cross marking his father's grave.

PAUL KELLER (1864-1923)

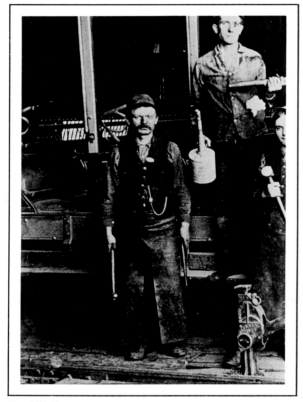

Paul Keller

FRANCES, daughter. I'm sorry I don't know more about my dad. He died when I was twelve. I know that he did very good work. He had a very good reputation. He always said, if you do a job do it right. In fact he was very proud of his work.

I remember the blacksmith shop. I often watched him shoe horses, he was kind to them and meticulous about the fit. My delight was to pull on the bellows to make the fire brighten in the forge.

My dad loved music and singing. He played by ear and whenever he visited someone with an organ he would play it by the hour.

He developed a wanderlust, so we moved often, different states and Canada.

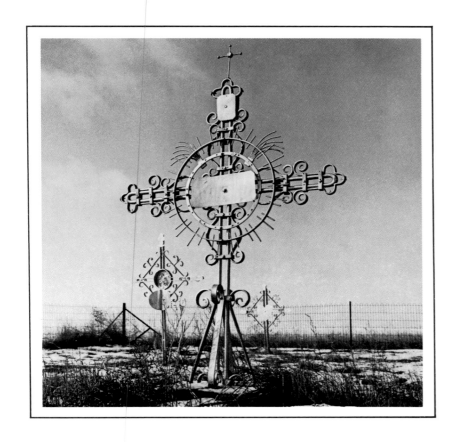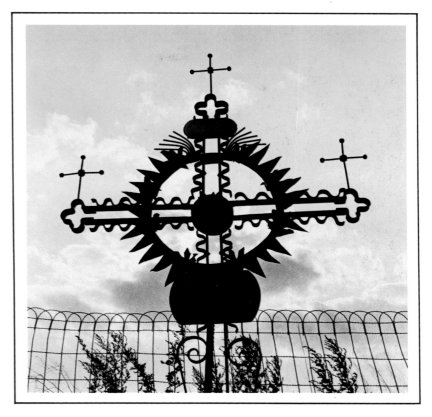

MICHAEL SCHMIDT (1875-1921)

JOHN. I knew the blacksmith real well, Mike Schmidt. As a little kid went to school, walked past the blacksmith shop. Usually had one settin there fixed for someone.

ANDREW. Ya I remember that old Mike forged them out of what he had. He was doing that until he died. It was the man that was the artist that made them.

KATIE. My husband had seven brothers and sisters buried out here and they all had mostly wooden crosses. Soon they broke off and then later on his dad had them made, that Schmidt Michael, he made seven of them. The way people wanted them, that's the way Schmidt made them.

MARY. He was a hard-working man. He would do it into the night.

JOHN. Even fixed his own cross. He knew he was gonna die. He knew it was coming. He was very ill.

MARY. I was almost on the bedside when he died. My folks knew him well, plus we children when we went to catechism school in town, we'd stay there. We were in the bedroom, they were praying. And I could never get over when he always said his shirt is too tight, and there was no shirt there. And he died that night.

I remember too, he was the good blacksmith. He did his work right. Always when there was something to be done, Michael Schmidt was the man.

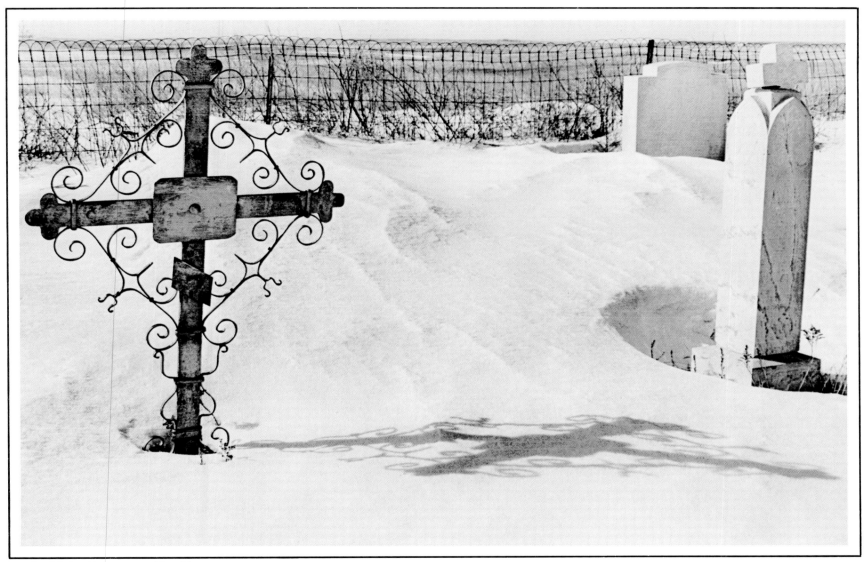

Michael Schmidt cross marking his own grave

JACOB FRIEDT (-1924)

KASPER. That's his grave and his cross. He was a widower, married a widow in town. He was always fixing shoes. He had a little shop in town. He was sittin in there with a couple of hammers and pliers. That's what he made that cross with in the shoe shop. He intentionally made it for himself.

He was a cream buyer and a shoemaker. That now is not necessary that he couldn't make that cross! We sold him cream. We came in and picked up the cream check, and there, had a couple of chairs and benches and I saw that he was working on that cross. He just prepared it in case.

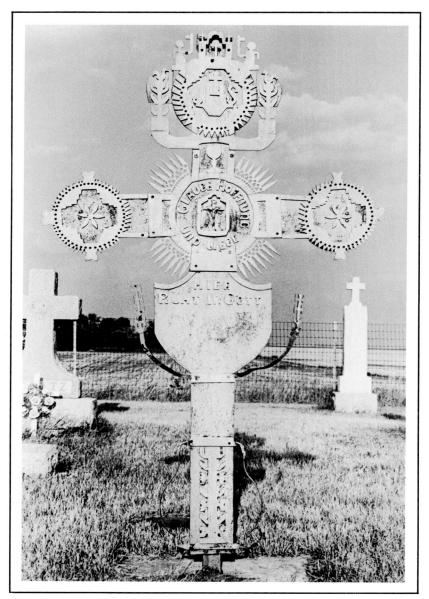

Jacob Friedt cross marking his own grave

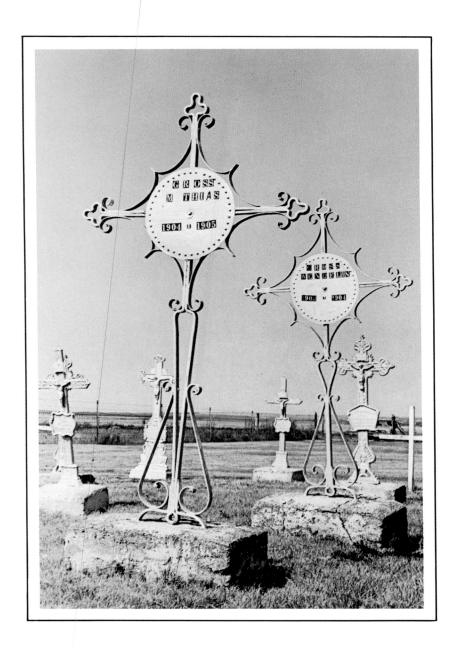

MARTIN DILLMAN (1887- ?)

LOUIS. I knew Martin Dillman. He learned blacksmithing from my grandfather. He was my relative. Didn't have a shop, worked on his farm.

JOHN. His farm was less than a mile away from ours. I remember he made them crosses. My brothers died a year apart. I don't think it was over twelve dollars for the two. Don't know if he made any others. Moved away around 1916.

JOHN KRIM (1882-1954)

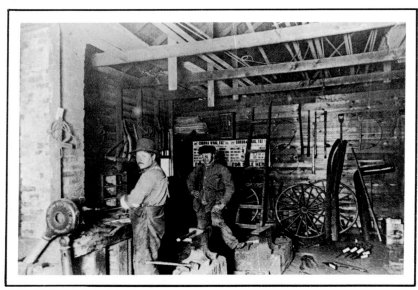

John Krim, left, in his shop

LENA, daughter. The first ones he ever made were for little children. He made them out of love for the kids. Very little money was exchanged, all he got was in the line of beef or mutton or wool.

GERTRUDE. Or the farmer probably brought in a little scrap iron, maybe give him a few pounds of scrap iron. This is what Uncle John made them for.

LENA. After he made quite a few, the people got to know. They were all immigrants. They knew they had to put a cross on when somebody died. And when they found out that Dad was making them, he had orders from all over.

LEO, son. He knew all those people because they used to be neighbors over in Russia.

CAROLINE. He was a very nice old man. He had a little chicken coop, he kept lay hens. And he had names for all his chicken. He was such a good old blacksmith. He did all kinds of work. Anything that broke, they rushed it to Krim. You just went down and you told him you wanted a cross. It did not take him long.

LEO. There was no blueprint on them at all. He'd just draw them into the sand. He'd go according to that. He'd just lay it out. I mean he had it in his mind what he was gonna build.

GERTRUDE. Oh many times I'd go down with mother. I'd go into the shop. He was a very quiet man. Not very many words at all. He was just all work. I would see him working, slaving away, making these crosses.

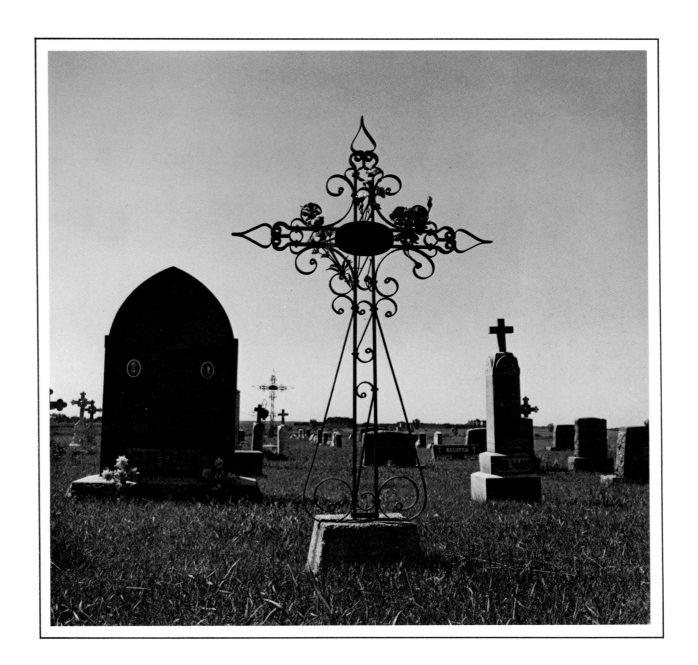

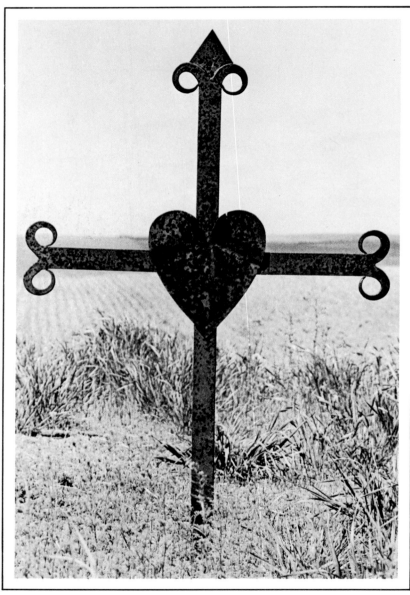

John Krim, cross maker

CAROLINE. He made so many, I think he could do it by heart.

LENA. He just loved to work with iron! For the grown-up people, he thought their crosses should be a little bigger, little more curves on them.

LEO. There's about five or six designs. Some he forged out the ends, somethin like a club on a playing card. All done in the forge. The way he fastened them up, he put a band around them, and he had that band hot when he put it around. And then of course it cooled off, it'd shrink up pretty tight. I worked with him until I was about twenty-four.

LENA. He had some stored in the shop and people would come and pick out which one they wanted. Then he would order the nameplate. All of us kids had to help paint these crosses. He did paint some silver, but it didn't stand up in the weather. So he used black.

CAROLINE. He did beautiful work and good work. When he built somethin, it was built. He didn't work just for the money, he worked more for his name. That Krim could do it.

JOE SCHMALZ (1887-1971)

JOE, son. It's just ornamental work, he was more interested because in the old country they trimmed wagons. He came from a family of blacksmiths. Earlier years there was a lot of decorative work done on wagons and buggies.

He bought his iron from a wholesaler. Usually he'd get a variety of stock. Some small scrap iron, some flat iron, some square, then the hard stuff for plowshare points. At that time it was Williams Hardware out of Minneapolis. That was shipped by train.

The design that he had in his mind, he followed that one design. He made it a business, three, four, five maybe, in the fall. The scrollwork was usually about one inch by a quarter. Then the main frame that was a little heavier.

I had to drill holes you know when I was younger. Dad would lay out the thing on the floor, course everything was marked for drilling, and I had to drill little holes so he could rivet the assembly. To me it was fascinating even as a child, and even up to now.

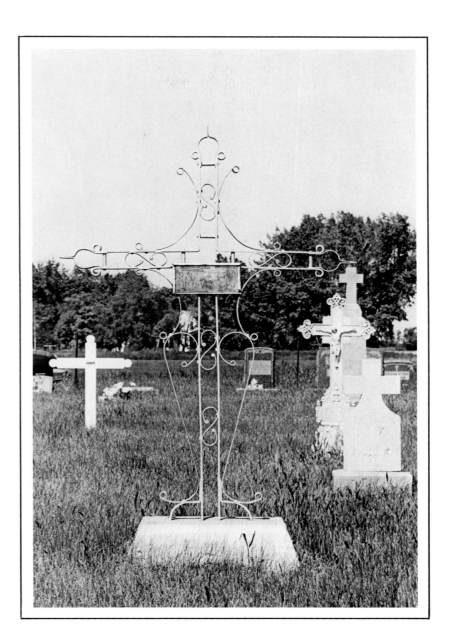

PHILLIP KUPSER (1882-1937)

Phillip and Margarada Kupser

ELIZABETH, daughter. We spent many, many, many hours in the blacksmith with our dad. When he put that iron in those coals this metal would turn from blue to red to white red and then to white. He loved that kind of work. He had a great knowledge of metal. Any kind, he could tell you by lifting or touching it.

I kinda think dad got the metal through Joe Schmalz because he had the shop in town. And I think he was able to get it shipped in for maybe three or four cents a pound. Sixty, eighty and a dollar some now.

He reminisced an awful lot of the old country. And how they used to make them over there. But in Russia they didn't have the stuff to make them with like here. So he made them more or less out of wood.

People would say, Phillip, would you make me a cross? It doesn't have to be so fancy, it doesn't have to be so big, just something so we know where they're at. They did not want to lose contact even of them as they were buried. Sometimes the crosses were made for a poor friend as a kind deed.

I remember when he welded them together with that borax. He poured it in an old sardine can and then when he'd start welding that together he'd dip it in that borax, put it together and pound it.

It gives me a feeling that he was a man of creation. My dad smoked a pipe and he'd whistle. He was the happiest man when he was in that blacksmith, pounding and working.

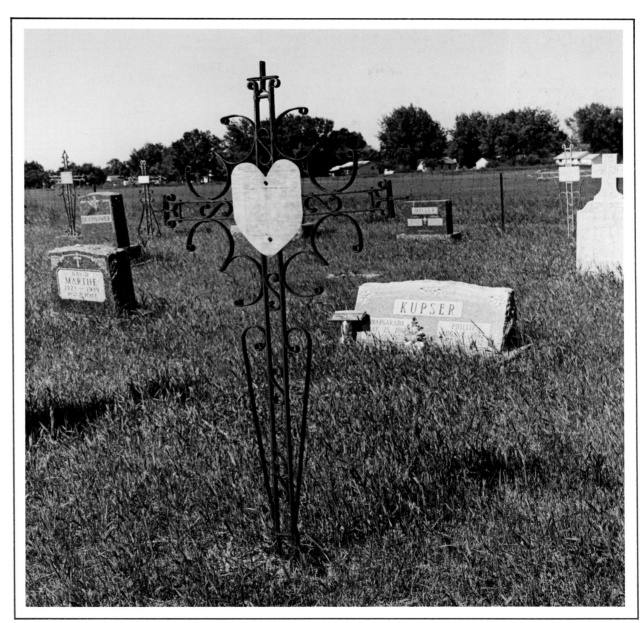
Phillip Kupser cross marking his father's grave

ANTON MASSINE (1871-1937)

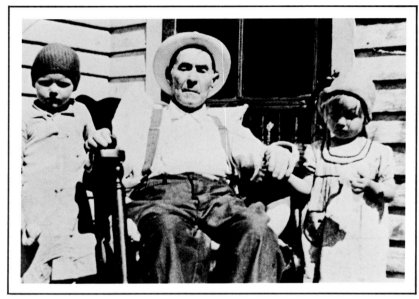

Anton Massine with grandchildren

CHRISTINE, daughter. I remember, the water was running down his face, sweating, it was hard work. And I remember him hammering to make them straight, and then bend them and then put them in hot coal. Bended them certain ways. And then he put them in cold water.

NICK, son-in-law. He made them out on the farm. I know one time he had three of them. Different sizes you know. I suppose he kept them on hand if somebody would come along and want one. He was gettin anywhere from fifteen to twenty-five dollars a cross.

CHRISTINE. Depends how fancy they were made, and how big, some were small, some were big.

He never talked. He just worked. I was just a little kid when I went in there. And you had to get out of his way, because when he hit on that iron, sparks flew away. They were red-hot. He always said, 'Get away! Don't get it in your eyes!'

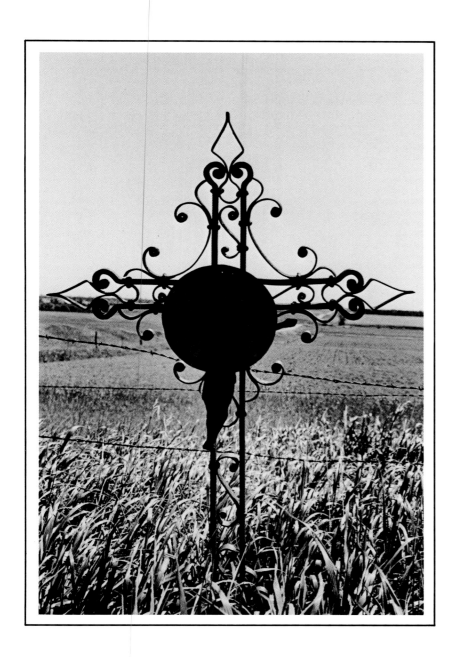

JOSEPH M. HAGER (1878-1957)

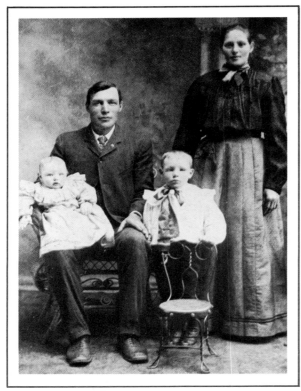

Joseph and Eva Hager family

FRED. You will run into a cross 'Moritz Hager'. That cross was made by Joseph M. Hager, who was the son of Moritz. I've seen Hager with his old bellows heat iron and make crosses. He had a little shop on the farm.

MIKE, son. He didn't make a business of it, he just made them, you know. He didn't charge any money for them. They were made for friends, ya.

FRED. He knew the art of welding iron the old-fashioned way. He musta learned it from himself.

MIKE. If we woulda asked him as long as he was alive, he could have given us a lot of information. But we never thought of something like that, it was nothing new at that time.

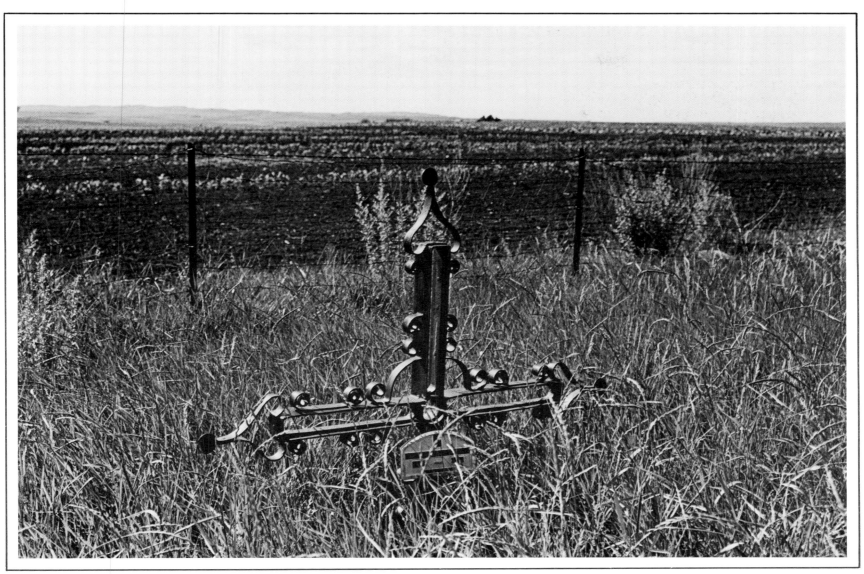

Joseph Hager cross marking his father's grave

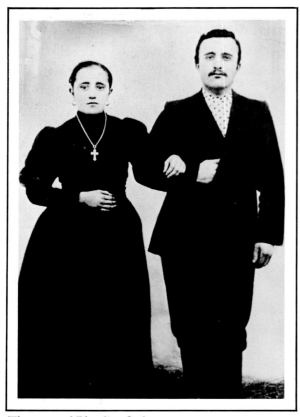

Thomas and Blandina Stebner

FLORA, daughter. Friends that he maybe knew from the old country wanted him to make them. He liked to do things like that. He liked to work with his hands.

Most of the things that he did, the way you distinguish them they had little arrows, pointed arrows here and there. And then too his spelling. You look at the crosses and you find out that his letters were backwards. Being that he was from the old country, he wasn't familiar with the spelling.

He had a shop on the edge of town in Sulz, Russia. When he came to this country, of course he had to go to some work and there was a blacksmith shop down here on Collins Avenue. He went in business with a Geiger, a couple of years only. He found that he couldn't make a living, they didn't have enough business. He went to work then for the railroad. Then he got himself a blower and a small forge at home in the basement.

I think they're most beautiful myself. It's all done by hand, every bit of it. How hard they worked, how they tried to accomplish something. The artistic end of it really has gone through the family.

It's something of his. As long as it's out there for everybody to see, why it's like in a museum you might say.

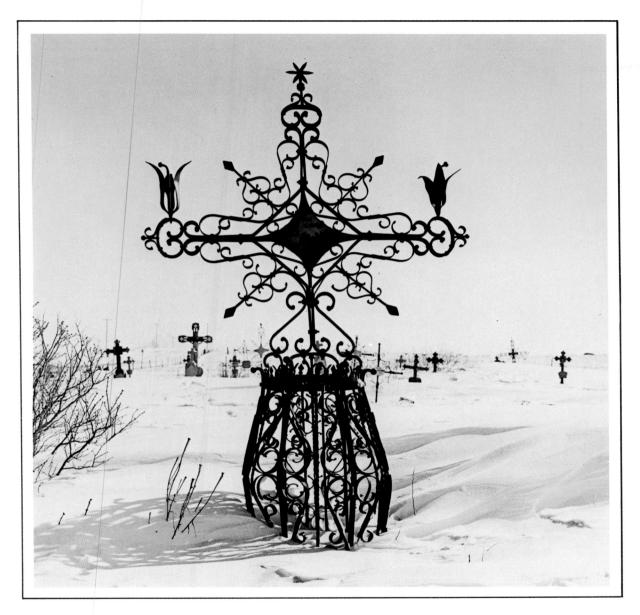

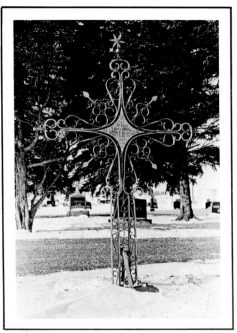

IGNATZ BOBB (1876-1962)

Ignatz Bobb with grandson

JOHN, son. He worked on a large farm in Russia. He learned it on his own I guess just by watching. He became the main blacksmith there. Here he went into farming, he liked it so much that he'd rather've done that. He quit the blacksmithing. People wanted him to do work, but he didn't want to. He did less all the time.

Exception ya, those crosses. He made them on the farm. It had to be a special friend when he worked on one of them. That was just the style at that time. Made his own designs. He'd draw it first on paper, it didn't take him long to figure it. Of course when he heard about something nice some place, he actually went and looked at it. This Mr. Stebner, they were pals even. They borrowed ideas.

Brother Alex, he was the youngest in the family. Burned to death about age five or six. I was working with him on that cross, close to Memorial Day. We looked, here a part, there a part, picked out of the yard, and fixed it together, in an hour it was done and put on. Some parts were already made from something else. The part it stands on, that was from a big boiler.

That's pretty hard to do. It's hard to get a person who can do that nowadays. I'll tell you what, anybody could give me a million dollar, I couldn't make a thing like that. I think it's in the person, they've gotta be born with it.

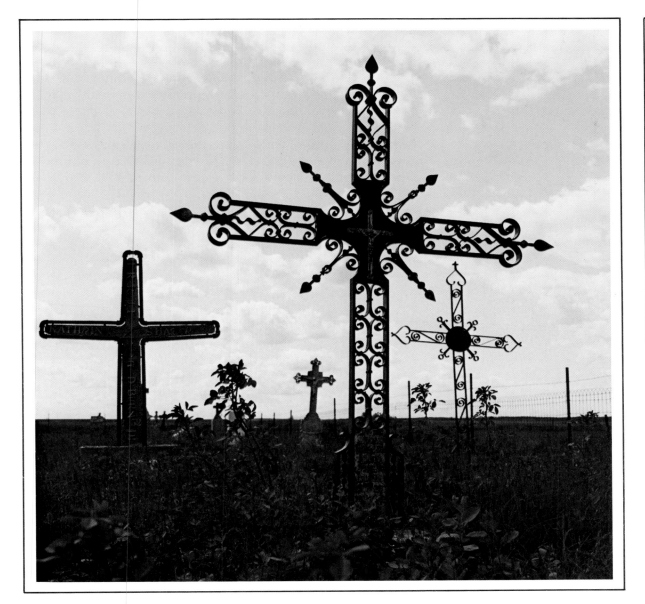

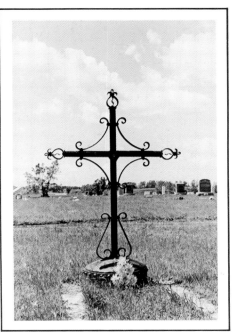

ANTON HUTMACHER (1867- ?)

JACK. He took them from wagon tires. Hammered them out. He'd take some lighter iron, like ribbon iron, and made those fancy whatchacallit. He did a nice job.

He was a real gentleman. Talked nice to people in kind of a quiet voice, explained things. The shop was going a number of years. He retired and went to California around 1922.

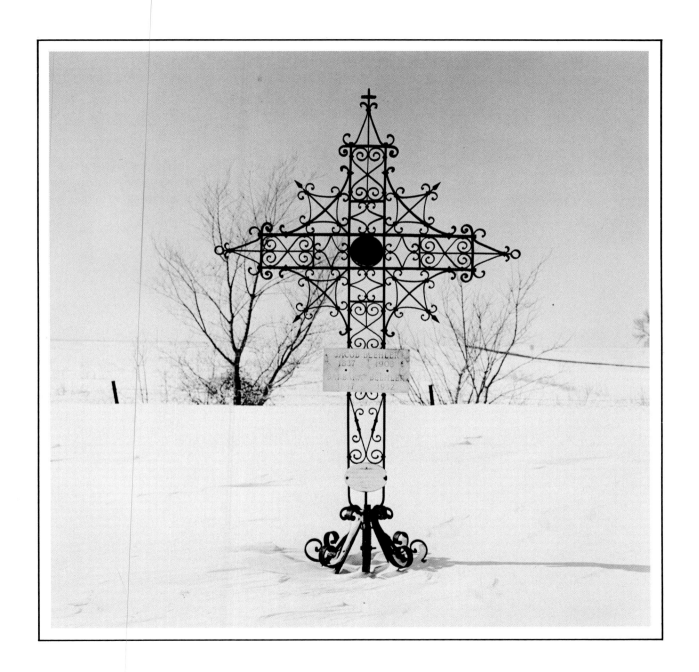

JOHN HEIDT (1862-1930)

GEORGE STREIT (1882-1941)

TONY. See Heidt, he put all those spikes in there. He made a lot of them crosses. Them days that was their living and they worked hard. And he didn't have no trip hammer. Boom, boom, boom, by hand.

John Heidt, he was by himself in the shop, then he died. Then George Streit moved in. And he built the cross for my mother. Mother died in '35, the poor times, see. I paid old man Streit thirty-five dollars. Oh my, them days we had to work for ten, fifteen dollars a month. And four dollars a month I had to pay him.

It isn't there no more. I was gonna save it, just for a souvenir. What happened to the cross I wouldn't know. It just disappeared.

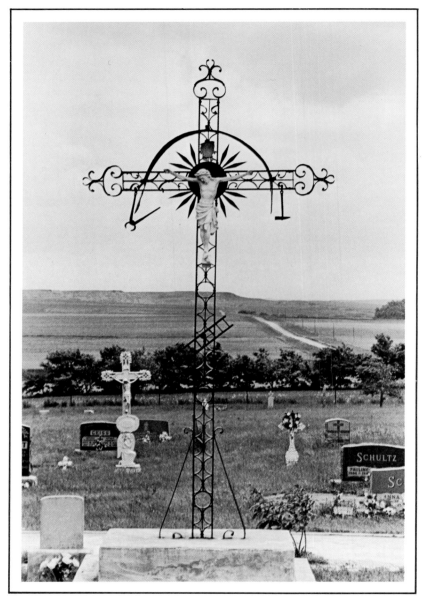

John Heidt, main cemetery cross

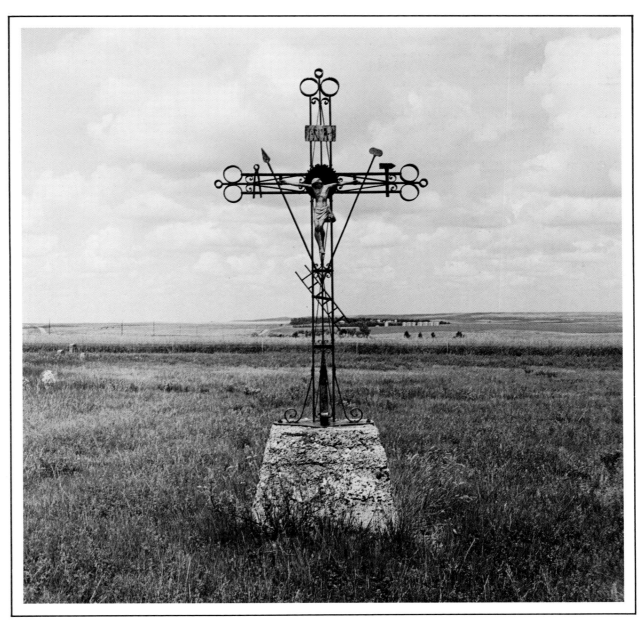

George Streit, main cemetery cross

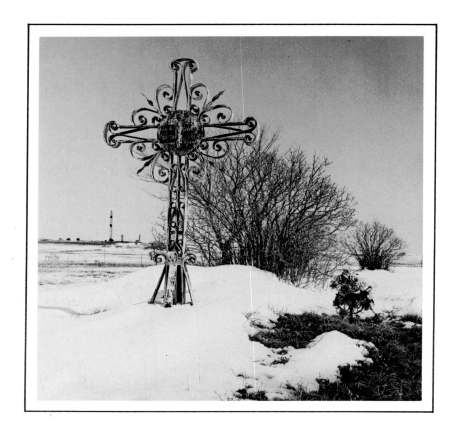

JOHN HOWIATOW (1873-1948)

MIKE, son. He come from the old country in 1909. His father was a blacksmith. And of course he collected from his father. He'd been helping other blacksmiths here, plus farming and selling clothes and so forth.

GEORGE. Ya, he was a salesman. So he peddled clothes and we got acquainted.

JULIA. Oh he was a very comical man. The way he would talk and show things!

GEORGE. He talked about it, that he's a blacksmith in the old country and he said he was gonna donate a cross for my mother, to have something from himself. Howiatow made that cross over the winter. Then we put it on there the next summer.

MIKE. I helped make it. Even the letters you know were made. I helped dad make the letters, I could spell out the names. They made a form out of mud. Made the little letters and pressed them in there, like a branding iron. Then we took the metal, some babbitt, and poured it in there. And then there'd be a plate with the name on it and you put it up on the cross.

GEORGE. It's a big remembrance.

MIKE. Other blacksmiths made them and he made them, it was a thing that was kind of a must.

JOHN PFEIFER (1879-1941)

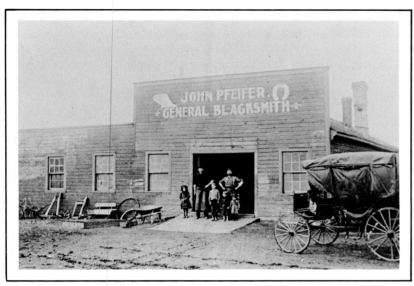

John Pfeifer, right, in front of his shop with friends

JULIUS, son. He was busy making wagons, wagon wheels, shoeing horses, made a lot of brands for the ranchers.

MIKE. I knew him. We had all our blacksmith work done there. Spend a lot of time when you come in and you pick up your lathes, and it wasn't quite done and you stop and talk with him.

JULIUS. Kids would come by after school and watch him working at the forge. He liked children. Big family, had eight. There was no rush to make a cross, everything else came first. He did that in his spare time. Pounded it out with a hammer and shaped it, couldn't do that without an anvil. Just worked it around that cone on the anvil. That's how he got the curves and everything else.

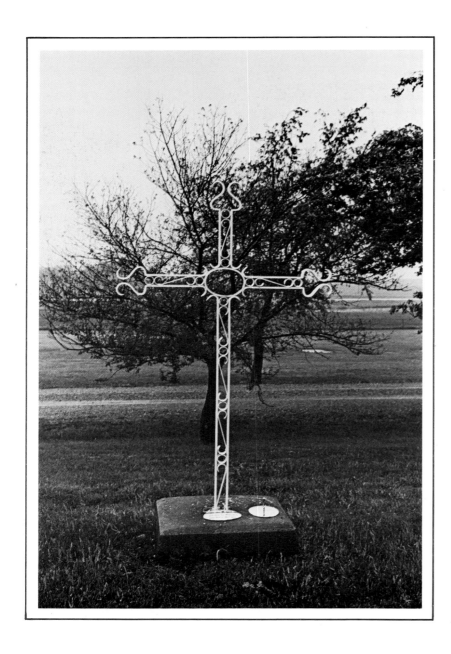

MIKE. He'd say, that's the pattern I got to make them crosses. Others make crosses too, but not like the ones I make.

JULIUS. I don't think he got more than ten, fifteen dollars. It was nothing to him, he didn't feel he was extraordinary because he could bend some iron. It was just daily routine.

Pretty soon the wagons didn't come, the trucks started coming. Business just fell off. About all he did towards the end was sharpen plowshares. And then he went into machine work. He saw the writing on the wall.

He was the oldtime village blacksmith, like you read in your third grade reader you know.

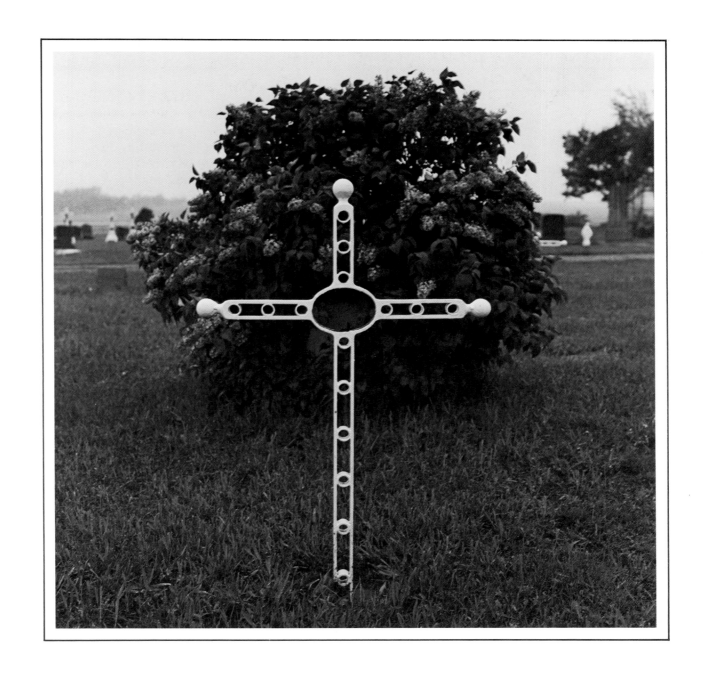

CONRAD SEGMILLER (1871-1929)

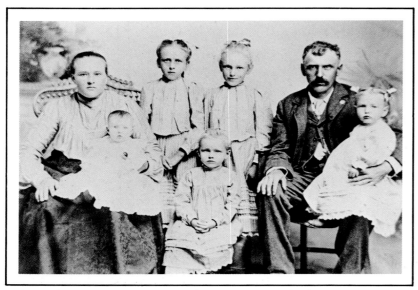

Conrad and Susanna Segmiller with five of their ten children

MARGARET, daughter. I don't see how he could do it! He had so few implements to work with. I can still see him when he was chopping with a hammer and chisel. He was particular about how things were done. He wanted a nice job and the crosses show it.

My folks came to America New Year's night 1901, and I was born that fall. In 1905 we moved to the farm. It's all down now I heard. You see father built that out of stone from the river, and he did a mighty fine job like he did of everything else. Blacksmith's shop he himself built. He did the blacksmith work for the farmers around. He knew all about that when he came. And then he did the crosses in between times. And other times he'd run the header and the binder, and plowed sometimes. Ya, he worked hard. The crops had to be put in too.

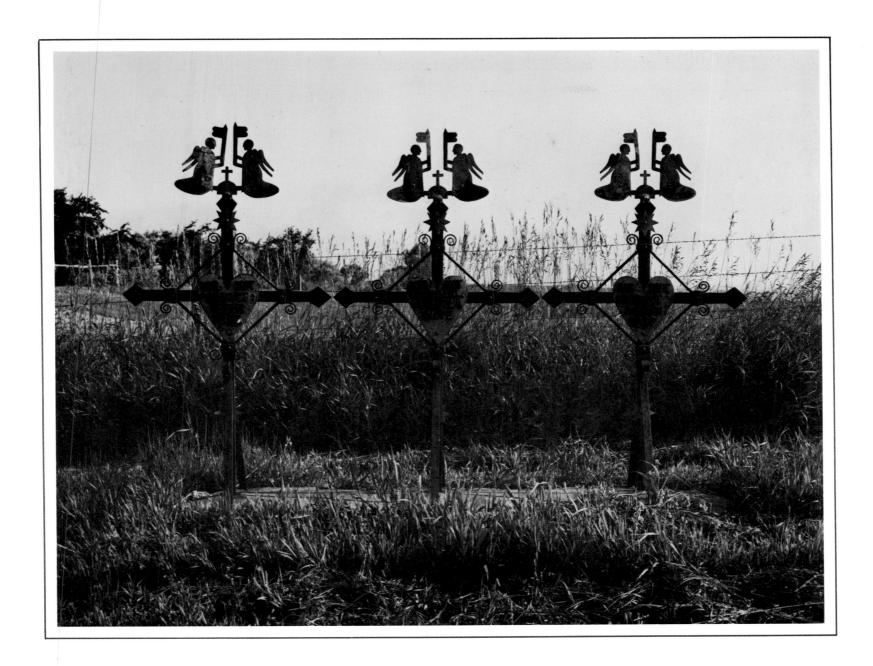

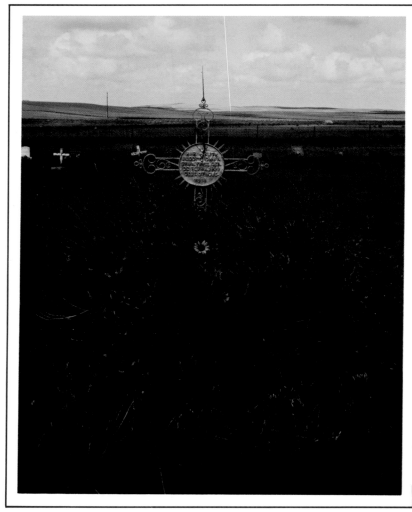

Conrad Segmiller, cross maker

Every year he seemed to have some crosses to deliver. Evidently he got orders from people. There were a lot of people that lived around here that knew my father from Russia. He'd make them in his spare time, most of them during the winter. When it was too cold to work out in the blacksmith he brought his drill in and screwed it on the wall in the kitchen and worked in there. Monica our sister remembers that she and mother helped drilling holes in the iron. The holes were drilled for that scrollwork.

I can still see him driving away from home with a load of crosses. The wagon had a double box with a rack which Dad made, and the crosses were all put on top, upright. Mike, Marie, Monica and I rememember that the crosses were painted blue. Monica said that she and mother painted them and that some were black also.

He made one for young children with a heart on it. And the other one was a round one, had those points out, with English lettering but German reading.

He never said much about it. He was kind of a quiet man. He didn't want us to get too close in the shop. But you marveled at it. Always gets me, the scrollwork, can't imagine how he could fashion that and make it look so perfect. I would like a cross like that when I die.

I don't think my dad was what you call a farmer. He liked better this blacksmithing work. He was an artist in his trade. All I can say is he did a real good job. We were absolutely proud of him.

JOHN PALUCK (1866-1938)

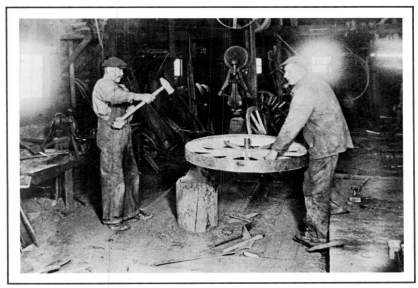

John Paluck, left, in his shop

ANTONIA, daughter. Mother was Ukrainian, father was Polish.

ALEX, son. Father and mother came by way of Canada in 1898 and homesteaded, had some friends who encouraged them to come. He got his blacksmithing idea at the Austrian army, his job was shoeing horses. I don't think he ever made any crosses in the old country. He maybe saw some made.

That blacksmithing was not a steady job. If it was threshing time, he had no time to blacksmith. He enjoyed that in the wintertime. That was kind of his sideline profit.

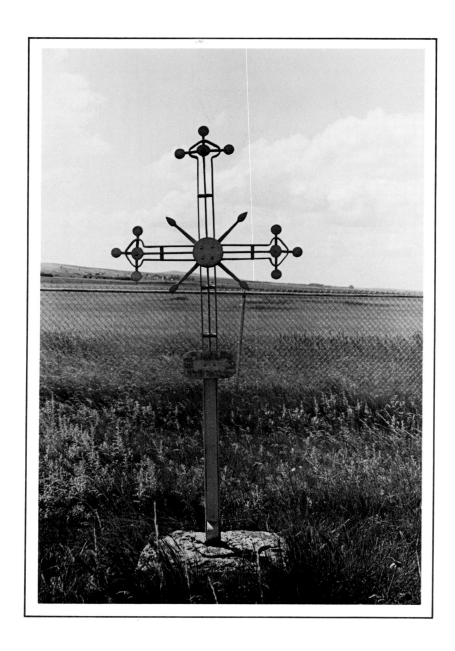

ANTONIA. It was mostly Ukrainian and Polish cemeteries that he made them for.

ALEX. People come out to the farm. He usually had some already made up. Once he got started, it went around. People themselves let the others know, as far as advertising. They were not too high-priced, fifteen dollars, maybe later up to thirty-five. He made iron crosses because folks couldn't buy expensive cast crosses or marble tombstones.

He used his own idea, compared them to some of those German Russians, they were making them, but a different type. The way he did it, it looked more simple, they weren't as cluttered.

ANTONIA. His own ideas, his own designs. He just made from his memory. When a person wants to make something, they do it.

ALEX. He had some talent for it and had a chance to use it. It was enjoyment for him to create something, handcraft, from his own idea. I think that was his most special work that he did.

He was quite a religious man, always had faith in the religion. Imagine he must have had some feeling, it went together with those crosses.

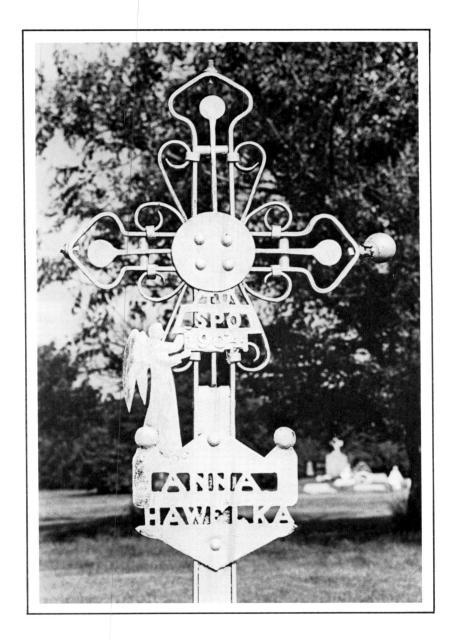

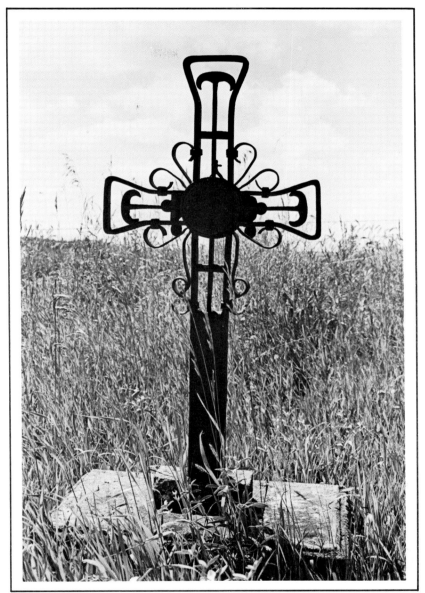

JOSEPH P. KLEIN (1876-1941)

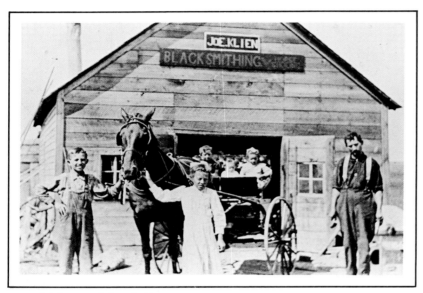

Joseph Klein with his children

PAUL, son.　The old blacksmiths were really a good blacksmith. Grandfather was one. He died in the old country when father was sixteen, and dad kept his blacksmith a going.

Dad landed in South Dakota someplace. Then he homesteaded up north. He made crosses for three to four parishes there. It was so sandy, he couldn't make a living. So he came here in 1920, farmed and had a blacksmith in town.

SABBIE.　I was right there a lot of times. I always admired the crosses. That's in the old blacksmith way.

PAUL.　It was a tinkering job, it was not a job like in springtime when everything was in a rush. The first one he made was for his father-in-law. He just had a pattern of his own. You take a scrap of iron, make the curves in there. He was so accurate. He just went by guessing.

JOHN.　Just come out of his head. He was a trade blacksmith and he'd kinda make that by himself, each one a little different, everyone a little fancier.

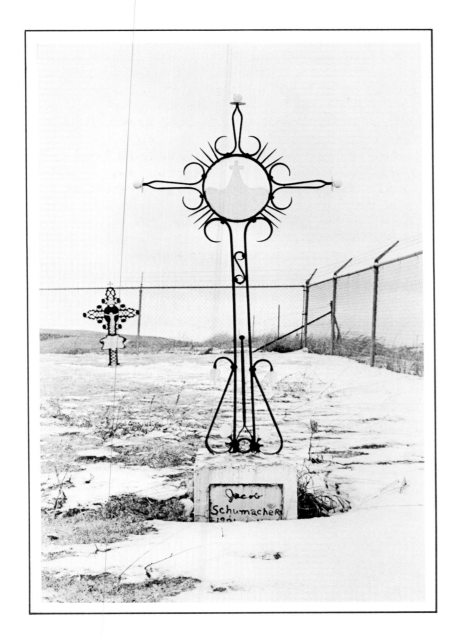

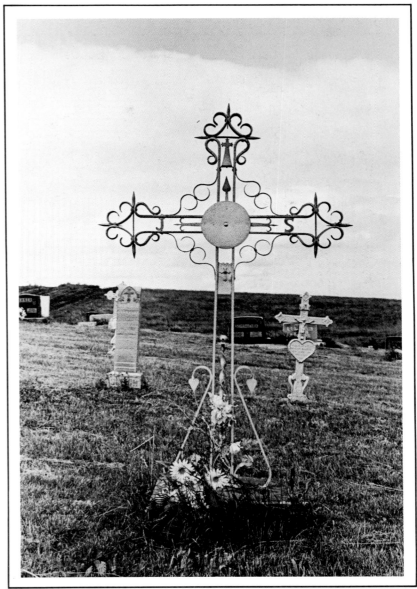

PAUL. The prettier he could make them, the better. He liked it. Some of them were easier, some were hard. Those round balls, he made them out of square shaft. Made a hole and cut the threads so he could turn it on.

I helped him long as far as I can remember, so much I could make them myself. Had to hold the iron, cranked the forge, pounded out heavy iron, the two of us hitting on the same piece. Dad didn't do writing on there, he just put the two initials on out of tin. We always painted them black.

SABBIE. The way they had em painted. Oh they're beautiful! I'd rather buy one of them than I would one of them stone ones, seems like it shows a little more skill.

JOHN. There was a lot of them. He said the hundreth one he's gonna make is gonna be for himself.

PAUL. The people longed for the iron crosses. But you know, they run out of style. I farm right against the cemetery, to the south side and from the west side, and don't you think there's thoughts! Those crosses that we made, and the funerals that there was for that person. By yourself you know.

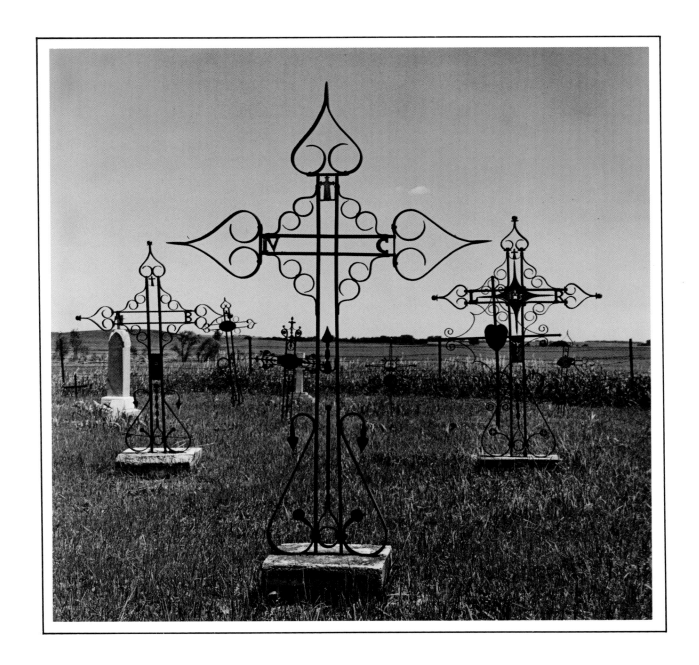

THE WORK

A blacksmith talks about the cross making.

ALBERT. You gotta get a nice good fire, a clean fire, you can't have any clinkers in there. Then you heat it up and it starts getting towards white. Some of them use sand, I use 20 Mule Team Borax. When that iron starts gettin white, I put that borax on there, right on the metal. And then I just keep heatin it until that metal starts flowing. When that metal starts shooting sparks, then you better have both of them ready, lay them on the anvil and pound them together.

The minute you got this iron hot, you've gotta get that hammer and get to it right now, because you let it cool off and then she won't bind on ya. When she was ready, there was no fooling around.

* * * * *

ALBERT. This is a lot of forge work. Took two strap irons for the arms, he tapered them down and welded them together. Then he heated that and started hammering that round. Then on the other end he made his bends, he tapered them, and flattened. That's all hammer work.

This center circle was a piece of strap iron. That was heated up and tapered down, half and half, both ends. And that was forge welded together. She's solid! One piece! They don't realize how much work's involved in this. That's hard work. No beefing about it.

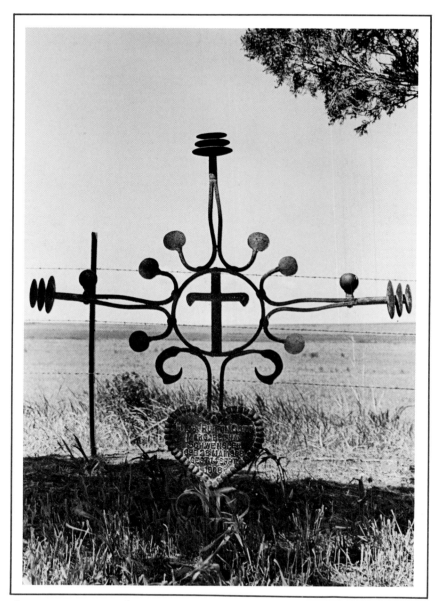

Anonymous cross maker

96

These are center punch marks. He marks them so he gets on the same circle. So each one where he made them for he could fit that in place to it. He's a good blacksmith, he's been using his head.

He tapered those bottom hooks out. Then he brought this to a point. Then while it's hot he laid that on the horn on his anvil and he just hammered it around. That's the reason the horn's on the anvil.

He cut these here and dished them, the discs at the ends.

He evidently bought that cast heart nameplate.

ALBERT. I betcha the man spent a better part of the month just doing this here, just how much hard work was in there. Time is so important now, you haven't got time to do anything like this. Them days they had it.

This is all handwork, you bet. That is plate steel. This backing and flat plate was in sheets, big sheets. No cuttin torches in them days, that would all have to be cut by hand.

Drilled it and riveted it. Every rivet you had to drill a hole. All these small pieces they had to be drill-holed. Them rivets are countersunk in, otherwise that would not hold in there. That was all done piece by piece.

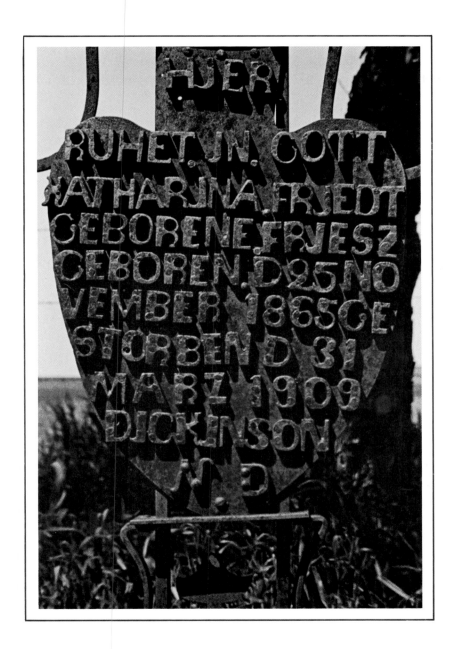

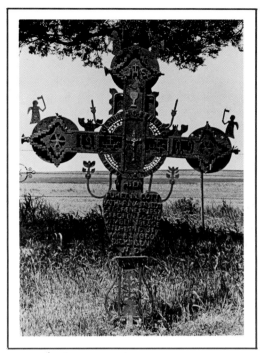

Jacob Friedt, cross maker

On the lettering drilled a hole here and here, say for the 'S'. Then you cut with a hack saw, then with a little filing you shape your letter. Them days they didn't have any emory wheels, mostly all done by files. Straight lines on the letters are all chisel work.

These are all riveted, see. That took a lot of patience and a lot of work. A terrific amount of work in there. Oh jeepers. There's at least a week's work right in there.

He probably enjoyed doing things like that. When you've got a hobby you know, you're not looking for how much work it's gonna take. You do it for the purpose of doing it, see what you can accomplish with it.

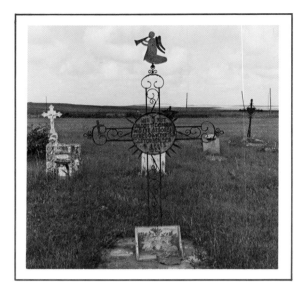

Conrad Segmiller, cross maker

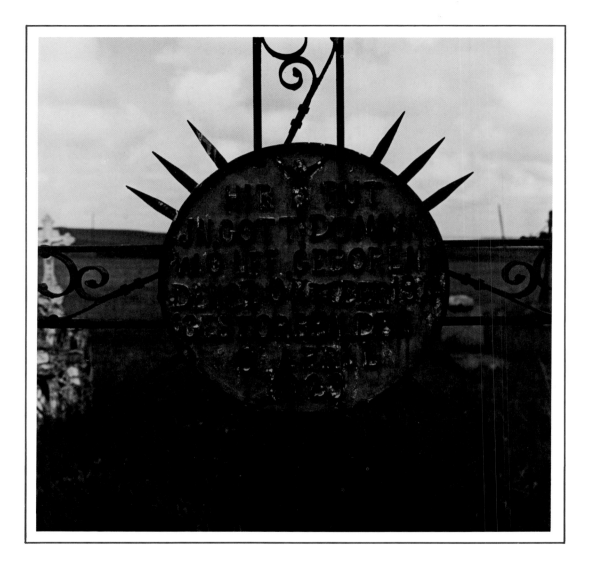

ALBERT. These here scrolls. They had a machine. This here is a strap iron and with that machine you could mold your iron any shape you wanted it. You pulled that lever and you shaped that iron. Curves are exactly the same size.

He's done careful work. You can see where he blended that end. He heated them up and pounded them over. Doubled them up. That is nice work. He was particular.

Used about an eighteen-gauge tin on the angel. That's chisel work, ya. Probably a half-inch chisel.

The spikes are chisel and forge work. He left a stem on, drilled a hole and then riveted them in.

This type of metal on the letters here they call it a band iron. You can make them cold, iron like this, you can bend these cold. He bended them. Clamp it in there, a vice, take a rod and just bend that iron around the right length and cut it off.

File it down to blend in here, see. Tapered down. Like this 'A' here, it's got a notch in here and a notch in here. The leg of the letter, that comes through the back. It had a tit on it. A hole drilled through the back, and then it's riveted.

This is good workmanship. He took pride in it. It's probably what he made his living on.

THE STUDY

A discussion of the crosses in a broad context of ethnicity and religion, treated in an academic manner for use as a tool for those who wish to pursue the subject further.

IRON LILIES, ETERNAL ROSES: German-Russian Cemetery Folk Art In Perspective

For
John P. Kloberdanz
(1938-1982)

Kein Kreuz mit eisernen Blumen steht auf
deinem einsamen Grabe, lieber Bruder.
Doch jeden Tag blühen die Erinnerungen auf
in den Herzen der Geschwister, Vater, Mutter.

On innumerable occasions, I have listened to German-Russians apologetically explain that since their pioneering forefathers were such a frugal and practical-minded people they simply had no time for art. Upon hearing this, I always would counter with a long list of examples of German-Russian folk art, ranging from meticulously embroidered *Haus Segen* (framed house blessings) to wrought-iron grave crosses. More often than not, the response to my list was a few moments of contemplative silence, followed by the inevitable query: "You mean those kinds of things are art?"

The fact that some German-Russians would react in the above manner should surprise no one, least of all professional folklorists. Even in those communities throughout the United States where folk art flourishes, there is often uncertainty as to what it really is. To complicate matters, folklorists and art historians themselves still engage in lively debates regarding the precise nature, characteristic features, and even definitional status of folk art.[1]

One reason why German-Russians sometimes fail to recognize many of their material culture traditions as folk art is because items such as *Haus Segen* and hand-crafted grave markers are seen primarily as utilitarian objects. The colorful German-Russian *Haus Segen* was hung on a wall of the family home to insure supernatural protection and to remind family members of their spiritual obligations. Wrought-iron grave crosses, while often highly decorative, were nonetheless used

with a very real purpose in mind: to mark and identify the final resting places of deceased individuals. Such practical considerations, however, do not rule out the possibility that certain traditional crafts can be treated as folk art. Indeed, as noted by American folklife specialist Henry Glassie, "the artistic nature of a folk artifact is generally subordinate to its utilitarian nature so that most folk art exists within the immediate context of folk craft."[2]

Of all the various material folk traditions known to the German-Russians, few have been the subject of so much attention and recent interest as that of the *schmiedeeiserne Grabkreuze,* or wrought-iron grave crosses. Particularly in North Dakota, where German-Russian Americans are an extremely large and visible ethnic group, there is a growing awareness of the wrought-iron cross tradition. There are many reasons for this, chief of which is the determination of the German-Russians themselves to promote their little-known history and cultural heritage. During the past fifteen years, two German-Russian ethnic societies have been established that (judging by their burgeoning memberships, numerous publications, and well-attended conventions) have enjoyed unusual success. Another reason is the increased attention given the German-Russian minority by scholars working in a variety of academic disciplines: anthropology, cultural geography, folklore, history, linguistics, and sociology. Due to this combined interest among both interested "outsiders" and the German-Russian people themselves, a once largely-ignored phenomenon like that of the wrought-iron crosses has become but one focus of intense interest and serious study.

Although it is doubtful if any state contains as many examples of German-Russian cemetery folk art as North Dakota, it was a Kansas folklorist, Samuel J. Sackett, who first studied the wrought-iron grave crosses of the Germans from Russia. Sackett focused on the so-called "steel crosses" found in numerous Volga German Catholic cemeteries in western Kansas and published his findings in 1976. (Sackett preferred the designation "steel cross" since his Kansas informants sought to avoid any association of the term "iron cross" with the German military decoration of the same name.)[3] In the spring of 1979, at a four-day conference on North Dakota folklore held at Jamestown College, one of the main presentations was devoted to a discussion of German-Russian cemetery folk art on the Northern Great Plains.[4] Recently, native-born North Dakotans of German-Russian ancestry also have turned their attention to the cemetery folk art of their home areas, including researcher Lewis R. Marquardt and genealogist Phyllis Hertz Feser.[5]

While wrought-iron grave crosses are widespread in those sections of North Dakota settled primarily by the German-Russians, it is important to remember that similar grave markers made by Germans from Russia are found not only in Kansas but also in South Dakota, western Saskatchewan, eastern Alberta, southeast Texas, and even as far south as central Argentina.[6] Among the German-Russians, the wrought-iron grave cross tradition is almost always associated with those groups who trace their ancestry to Roman Catholic colonies in either the Black Sea or Volga River regions of Russia. The German-Russian Catholics who settled in the Dakotas, western Canada, and southeast Texas, came primarily from agrarian villages in the Black Sea region near the port city of Odessa. Those German-Russian Catholics who made their homes in the central Great Plains states (e.g., Kansas) and in South America came from an older area of German settlement on the lower Volga.

Due to the different historical backgrounds of the Black Sea Germans and the Volga Germans, it is at times difficult to lump these two German-Russian groups together in order to

arrive at generalizations. This is especially true when one considers the wrought-iron grave cross tradition known to both groups. The Volga Germans, for example, did not bring with them from Russia the custom of making or using wrought-iron crosses. All available evidence indicates that this was a practice that was adopted shortly after their arrival in the New World. In their cemeteries in Russia, the Volga Germans used wooden crosses quite extensively. Following immigration, wrought-iron grave crosses were adopted either through close association with Black Sea German Catholics (as occurred in the St. Joseph's Colony area of western Saskatchewan) or as a result of seeing commercially produced iron crosses elsewhere (as was the case among Volga German Catholics in western Kansas).[7]

There is ample evidence, however, that the use of wrought-iron grave crosses among Black Sea Germans in Russia was relatively common. Published sources, as well as interviews with Russian-born Black Sea German informants, indicate that the practice of making and erecting *schmiedeeiserne Grabkreuze* was well-known in the Odessa region. Father P. Konrad Keller — an early historian of the German-Russian colonists — published a two-volume work in which he noted that in Black Sea German Catholic cemeteries in Russia each grave customarily was "identified by a wooden or iron cross."[8]

Reasons why Black Sea German colonists used iron cemetery crosses — while the Volga German colonists in Russia did not — remain something of a mystery. Wrought-iron grave crosses were used by the Ukrainian population in the Black Sea area (indeed, beautiful iron crosses are to be found in Ukrainian-American cemeteries in North Dakota even today). Thus, Black Sea German Catholic cemetery folk art may have been influenced by Slavic preferences and traditions. More likely, however, is the possibility that the wrought-iron grave

cross tradition was one that the Catholic German colonists were already familiar with when they first established their villages in the Black Sea region during the early 1800s. Elaborate, wrought-iron grave crosses were produced by craftsmen in what is now southern Germany as far back as the Renaissance period, when ironwork was extremely popular. At the time of the Black Sea German migration in the early nineteenth century, wrought-iron grave markers could be found in Alsace, the Palatinate, Baden, Bavaria, and other provinces from which many Russia-bound colonists emigrated. Proof for the wrought-iron grave cross tradition in southern Germany is so widespread that German folklorists have been able to link certain iron cross designs and methods of construction to specific geographical areas.[9]

Additional evidence that the wrought-iron grave cross tradition among the Black Sea Germans may reflect the persistence of traditional funerary practices known in the German homeland — rather than Slavic influence — can be inferred by examining the cemetery folk art of other Catholic emigrant groups who went directly to the New World from Germany. The Bavarian-Germans who settled in the lush hills of southern Indiana during the mid-nineteenth century, for example, also fashioned and used a variety of wrought-iron cemetery crosses, many of which are still visible today.[10]

In any discussion of the wrought-iron cross tradition among the Germans from Russia, it must be remembered that this phenomenon represents only one manifestation of the full range of German-Russian cemetery folk art. In North Dakota and in the Canadian prairie provinces, one also finds handmade wooden crosses in both Catholic and Protestant German-Russian cemeteries. Unfortunately, many of these markers often show varying degrees of deterioration, due to the rigors of time and the extremities of Great Plains weather. In western Kansas, where rows of wrought-iron

crosses grace the level landscape, German-Russian Catholics sometimes fashioned grave markers out of native limestone. While some of these hand-carved markers reflect traditional tastes and styles, others clearly show a determined effort to duplicate the staid appearance of commercial tombstones. In the north central section of North Dakota, where Catholic German-Russians from the Kutschurgan region of South Russia settled, a number of cement grave markers were produced by craftsmen in the 1920s and 1930s. Some of these monuments are particularly striking, due to their large size and unusual design. Quite often, such cement grave markers were embellished with colored pebbles or jewel-like bits of crushed bottle glass. In some instances, too, the German inscription on the markers was accompanied by carefully incised symbols and decorative motifs (e.g., sprigs of evergreen or cedar).

The materials and techniques used by German-Russian craftsmen in designing various cemetery markers often reflect economic as well as aesthetic considerations. In the earliest days of German-Russian settlement in North Dakota, cemetery crosses of wood were quite common. Later, as the emigrant settlers became increasingly self-sufficient and local blacksmiths had become established, individual wrought-iron crosses were produced. In the early 1900s, the use of foundry or cast-iron cemetery crosses (gusseiserne Grabkreuze) became popular. These commercial markers frequently were promoted in the advertisement sections of German-language newspapers. In sharp contrast to the long wait that sometimes resulted when wrought-iron crosses were made by local blacksmiths, cast-iron crosses could be purchased and erected relatively promptly.

The extent to which the commerically produced, cast-iron crosses influenced the making of traditional wrought-iron crosses among the Germans from Russia is a fascinating subject about which very little is known. No German-Russian community in sparsely-settled North Dakota (or anywhere else for that matter) was wholly isolated from the influences of the dominant society. Indeed, German-Russian cemeteries may well provide a visible index for the study of the Americanization process and culture change. Such a study would have to take into account a wide variety of important considerations: the physical layout of the cemetery; the types of cemetery folk art evident (e.g., wrought-iron crosses, cement grave markers); the use of German or English inscriptions on the grave markers; the placement of graves in relation to age, sex, social relationship, and economic status; religious symbolism; the use of patriotic motifs on commercial tombstones; etc. Of all these considerations, the phenomenon of cemetery folk art — because it reflects the dynamic relationship between the cultural tradition of a people and the expressive spirit of individuals — is of special significance.

In studying the wrought-iron grave cross tradition among the German-Russians, one becomes aware of the vital role of the individual folk artist. The German-Russian blacksmith who fashioned wrought-iron crosses was working within a cultural tradition and thus made wide use of familiar designs and symbolic motifs, some of them quite ancient. Yet each German-Russian blacksmith left an unmistakable personal stamp on his finished product, without actually having to etch his name or initials. Individual styles and levels of expertise were so distinct among German-Russian cross makers that even today — many decades after their creation — most wrought-iron crosses can be linked to the names of the men who made them. Thus, the interested observer can single out the wrought-iron crosses of the German-Russian blacksmith Mike Prediger in the St. Joseph's Colony area of Saskatchewan; the haunting vertical pieces of Alois Hauser amid the horizontal wheat fields of western Kansas; and the

expert workmanship of the emigrant blacksmith Thomas Stebner in North Dakota. The wrought-iron crosses made by these prairie craftsmen serve as powerful reminders that folk art exists not only to affirm cultural tradition but also "to allow man to explore his innovative nature . . . [and] to delight."[11]

The various manifestations of German-Russian cemetery folk art — particularly wrought-iron grave crosses — defy adequate understanding in and of themselves. In order to better comprehend what the crosses mean to the German-Russian people who once made and used them, it is necessary to view these artifacts within their broad cultural context. To do this, one must step back and try to see beyond the wrought-iron crosses of North Dakota to other places where there is evidence of the same phenomenon. (This attempt at increased perspective on my part is no mere scholarly exercise, as attested by the German-Russian proverb: "*Die Weit ist besser für den Schuss* — Distance is better for one's aim.")

How does one explain the persistence (or in some cases, the acceptance) of the wrought-iron grave cross tradition among such diverse and far-flung German-Russian groups as Black Sea Germans in the Dakotas, Volga Germans in western Saskatchewan and Kansas, Black Sea Germans in southeast Texas, and Volga German *labradores* on the pampas of central Argentina? Despite their regional and historical differences, all of the above groups share a number of important things in common: the same ancestral homeland; dialectal varieties of the same German language; an emphasis on close family ties; and a strong agricultural orientation. More importantly, those German-Russians who made and used wrought-iron crosses in the New World — whether in North Dakota or in South America — were primarily Roman Catholic and shared similar attitudes toward life, death, and

the hereafter. Thus, Catholicism served as an important unifying force, particularly in regard to cultural values and shared perceptions. German-Russian Catholics — like Catholics in peasant societies around the world — tended to emphasize visual symbols rather than oral ones. Consequently, German-Russian Catholics saw both meaning and beauty in such things as religious shrines, statues of the saints, Mass vestments, the monstrance, and decorative wrought-iron grave crosses. Many German-Russian Protestants, on the other hand, tended to stress simplicity and far less visual (but equally emotion-laden) symbols such as holy scripture.

The traditional view of many German-Russian Catholics toward life tended to be colored by an ever-present awareness of death, as evidenced by a number of old country proverbs and folk expressions: *Heit rot, Morje tod* (Here today, gone tomorrow); *D' Junge kenne, d' Alte misse* (The young can die, the old must); and *Umsunscht isch d'r Tod, un der koscht noch's Lewe* (Death is free of charge, but it costs you your life).[12] Death was seen as a natural and inevitable part of the life process; it was not so much feared as it was merely acknowledged. (Even today, some German-Russians in the Dakotas eagerly show visitors thick photograph albums that include pictures of stoic family members gathered around the open coffin of a deceased relative.)

German-Russian Catholics particularly respected the consecrated ground of their dead and affectionately referred to the cross-studded cemetery as the *Friedhof* (literally "peace yard") or *Gottesacker* (God's acre).[13] A few individuals poetically spoke of the parish cemetery as a *Rosengarten* (rose garden). Indeed, on some German-Russian grave crosses and tombstones in North Dakota, a German inscription similar to the following might appear:

Hier in diesem Rosengarten,
Muss ich auf meine Frau und Kinder warten.

(Here in this rose garden,
I must await my wife and children.)

The funeral customs of German-Russian Catholics have changed significantly since the early 1900s when wrought-iron cemetery crosses were in wide use. In both Old Russia and the early German-Russian settlements in the New World, death was tolerated like an uninvited but periodic house guest. Following a death in the German-Russian community, the wake leaders, grave-diggers, coffin-makers, and funeral cooks often went about their tasks in a matter-of-fact fashion. Death was truly a community affair, for with the loss of each parishioner, a precious piece of the community fabric had been rent asunder. Nevertheless, to the German-Russians, death was not a particularly cruel or unjust force. *"Der Tod macht alle gleich,"* German-Russians liked to remind themselves, "Death makes everyone equal."

The image of death as an inevitable and impartial force was reaffirmed at each German-Russian Catholic funeral when the mourners gathered around the grave for the final blessing. In the early 1900s, burials among German-Russian Catholics in the Dakotas were conducted much as they had been in Russia. After the priest concluded the prayers at the cemetery, he traditionally placed the first shovel full of earth on the lid of the coffin to remind everyone that "thou art dust and unto dust thou shalt return." The coffin was then slowly lowered into the grave by the pallbearers. It was at this time that the finality of this tearful rite of separation reached a dramatic peak. The choir members and assembled mourners, who watched as the coffin slowly descended into its final resting place, intoned the traditional burial hymn, "Das Schicksal":

Das Schicksal wird keinen verschonen,
Der Tod verfolgt Szepter und Kronen;
Eitel, eitel ist zeitliches Glück
Alles, alles fällt wieder zurück.

Der Leib, von der Erde genommen,
Kehrt dorthin woher er gekommen.
Reichtum, Schönheit, Witz, glänzende Macht—
Alles decket die ewige Nacht.[14]

Fate will spare no one,
Death pursues scepter and crown;
Empty, empty is fleeting fortune
Everything, everything comes to an end.

The body which was taken from the earth,
Returns to the place whence it came.
Wealth, beauty, wit, glittering power—
All are covered by the eternal night.

The hymn — which was sung from the viewpoint of the deceased — stressed the temporal nature of all things, particularly the fragile quality of human existence. While "Das Schicksal" echoed the faint hope of eternal promise, the song placed far greater emphasis on the all-too-temporary and ill-fated existence of the living. Unforgettable imagery was used in the burial humn to convey to the huddled mourners a sense of their own destiny:

Die Zedern verfaulen wie Stauden,
Die Rosen verwelken wie Rauten.
Alles unter der Sonne vergeht,
Nur die einzige Tugend besteht.[15]

Cedar trees rot away like bushes,
Roses wilt like withered herbs.
Everything under the sun disappears,
Virtue alone is everlasting.

Although the singing of ''Das Schicksal'' rarely pierces the stillness of prairie cemeteries today, grizzled German-Russians still speak of this act of lamentation with voices that betray deep emotion. And yet one must remember that the burial hymn — though once sung by grieving German-Russians on the European steppes, North American plains, and South American pampas — was not a song that grew out of the common traditions of the people. As an official dirge, ''Das Schicksal'' was an integral part of the early Roman Catholic burial rite among German-speaking peoples in the Old and New Worlds. Regardless of where the hymn was sung, the mournful melody and haunting lyrics were much the same. This was in sharp contrast to the ''unofficial'' tradition of making wrought-iron grave crosses that reflected the rich cultural legacy and varied tastes of their makers. Perhaps for this reason, the elegantly-crafted iron crosses of the German-Russians seem to challenge — rather than piously reaffirm — the disconsolate message of the official burial hymn.

The wrought-iron grave crosses of the German-Russians — with their unbroken hearts of metal, brightly-painted stars, endless circles, banner-waving angels, sunburst designs, power-charged lightning bolts, exquisitely-formed lilies, and rose blossoms that rust but never wilt — evoke the defiant spirit of their mortal makers. In a bold effort to transcend the finite, this defiance was tempered and hammered into the timeless language of iron.

Timothy J. Kloberdanz

Timothy J. Kloberdanz is an assistant professor in the Sociology-Anthropology Department at North Dakota State University. His specializations include cultural anthropology, folklore, ethnicity, North American Indians, and the Germans from Russia.

NOTES

1. See, for example, *Perspectives on American Folk Art,* ed. by Ian M. G. Quimby and Scott T. Swank (New York: W.W. Norton and Co., 1980.)

2. Henry Glassie, ''Folk Art,'' in *Folklore and Folklife: An Introduction,* ed. by Richard M. Dorson (Chicago: University of Chicago Press, 1972), p. 253. Also see the essay on ''Folk Crafts'' by Warren E. Roberts in the same volume, pp. 233-252.

3. Sackett's publications on German-Russian iron grave crosses include ''Steel Crosses in Volga German Catholic Cemeteries in Ellis, Rush, and Russell Counties, Kansas,'' in the *American Historical Society of Germans from Russia Work Paper,* No. 21 (Fall 1976), pp. 20-24. A similarly-titled piece appeared in *Heritage of Kansas* 9 (1976), No. 2 & 3, pp. 82-93.

4. The slide/paper presentation, entitled '' 'In this Garden of Roses': Russian-German Funerary Folk Art on the Northern Great Plains,'' was given by Timothy J. Kloberdanz on April 3, 1979.

5. Lewis R. Marquardt's research has dealt primarily with wrought-iron crosses found in south-central North Dakota. See his two articles ''Metal Grave Markers in German-Russian Cemeteries of Emmons County, North Dakota,'' in the *Journal of the American Historical Society of Germans from Russia* 2 (Spring 1979), pp. 18-26 and ''Eiserne Kreuze of Emmons County: A Forgotten Folk Art,'' in *Heritage Review* 10 (April 1980), pp. 11-16. Phyllis Hertz Feser has focused on the wrought-iron cross tradition among Beresan German-Russians in western North Dakota, as evidenced by her article ''Gottesacker'' in *Heritage Review* 10 (April 1980), pp. 17-20.

6. Iris Barbara Graefe, *Zur Volkskunde der Russlanddeutschen in Argentinien* (Vienna: Verlag A. Schendl, 1971), pp. 123, 150.

7. Sackett, ''Steel Crosses in Volga German Catholic Cemeteries,'' p. 20.

8. See Rev. P. Konrad Keller's *The German Colonies in South Russia* (originally published under the title of *Die deutschen Kolonien in Südrussland,* Odessa, Russia, 1914), vol. II, trans. by A. Becker, (Saskatoon, Saskatchewan: Mercury Printers, 1973), p. 293.

9. See the section on ''Grabdenkmäler'' in *Wörterbuch der deutschen Volkskunde,* 2nd ed., compiled by Richard Beitl (Stuttgart: Alfred Kröner Verlag, 1955), pp. 271-273. Also see the 1931 study by J. Ringler entitled *Schmiedeeiserne Grabkreuze.*

10. For an introduction to the Dubois County German-Americans of southern Indiana, see Norbert Krapf's *Finding the Grain* (Jasper, Indiana: Dubois County Historical Society, 1977).

11. Henry Glassie, ''Folk Art,'' p. 276.

12. For a list of representative proverbs among Black Sea German Catholics, see Joseph S. Height's *Paradise on the Steppe* (Bismarck, North Dakota: North Dakota Historical Society of Germans from Russia, 1972), pp. 154-159.

13. While German-Russian informants invariably explain the etymology of *Friedhof* as stemming from the German word ''Friede'' (peace), it is more likely that *Friedhof* is derived from the medieval German term ''Frithof,'' meaning a place enclosed by a wall or hedge. See Hans-Kurt Boehke, *Das Bestattungs- und Friedhofswesen in Europa* (Vienna: Europäische Bestatten-Union, 1977), p. 84.

14. From the *Geistliche Halszierde Gebet und Gesangbuch* (Budapest, 1894), No. 609. English translation of German lyrics by Emma S. Haynes and Timothy J. Kloberdanz.

15. Ibid. This verse sometimes was omitted in later editions of the hymnal used by German-Russian Catholics.

·

PHOTOGRAPHERS

Jane Gudmundson is a photographer and fiber artist who has exhibited her work regionally. She is English and currently teaches in the Fargo school system.

Wayne Gudmundson has had exhibits at Film in the Cities, Minneapolis; Plains Art Museum, Moorhead; North Dakota State University Art Gallery, Fargo; and Ralph's Bar, Moorhead, as well as participating in numerous group shows. He currently manages the Creative Arts Studio in Fargo.

The Gudmundsons have recently completed work on a book, *Oil, Photographs from the Williston Basin.*

PHOTO CREDITS

Jane Gudmundson: on pages 7, 8, 12, 13, 14, 24, 26, 33 (two photos), 36, 51, 54, 55, 61, 62, 63, 66, 67, 71, 73, 75 (vertical photo), 77 (vertical photo), 80, 84, 90, 91 (two photos), 93 (two photos), 96, 97, 98, and 99 (two photos).

Wayne Gudmundson: cover and on pages 3, 4, 5, 9, 11, 15, 23, 25, 27, 28, 29, 31 (two photos), 35, 37, 38 (two photos), 39, 52, 53, 56, 57, 59 (two photos), 65, 69, 75 (square photo), 77 (square photo), 79, 81, 82, 85, 87, 88, 95 and 100 (two photos).

Historical photos: pp. 43 and 47, courtesy of Joe Schmalz, Jr.; p. 50, courtesy of Angeline Schneider; p. 58, courtesy of Frances Kirkes; p. 64, courtesy of Leo J. Krim; p. 68, courtesy of Elizabeth Job; p. 70, courtesy of Christine Axtman; p. 72, courtesy of Mike Hager; p. 74, courtesy of Flora Weinhandl; p. 76, courtesy of John Bobb, Sr.; p. 83, courtesy of Julius Pfeifer; p. 86, courtesy of Margaret Segmiller; p. 89, courtesy of Alex and Antonia Paluck; and p. 92, courtesy of Anna Schumacher.

MARGARET. Angel of God, my guardian dear, To whom
God's love commits me here, Ever this day be at my side, To
light, to guard, to rule and guide.